P9-CBK-620

Art & Discontent

Theory at the Millennium

Thomas McEvilley

DOCUMENTEXT
McPHERSON & COMPANY

Copyright 1991 by Thomas McEvilley. All rights reserved.
Published by McPherson & Company, Publishers, Post Office Box 1126, Kingston, New York 12401. Designed by Bruce R. McPherson. Typeset in Bembo by Delmas Typesetting, Inc. Manufactured in the United States of America. First paperback edition, March 1993.
3 5 7 9 10 8 6 4 2 1993 1994 1995

Library of Congress Cataloging-in-Publication Data

McEvilley, Thomas, 1939–
 Art and discontent: theory at the millenium / Thomas McEvilley.
—1st ed.
 p. cm.
 ISBN 0-929701-13-5 (alk. paper)
 ISBN 0-929701-31-3 (pbk.)
 1. Aesthetics. I. Title.
BH39.M434 1991
701'.1—dc20 90-48316

Grateful acknowledgment is made to the publishers of earlier versions of the essays comprising this book:
 Artforum magazine: "Introduction" under the title "Forum," April 1984; "Heads It's Form, Tails It's Not Content," November 1982; "On the Manner of Addressing Clouds," June 1984; "'I Am,' Is a Vain Thought" as "Ankebuta, An Ancient Babylonian Scientist," May 1983.
 "Art History or Sacred History?" was first published as "Histoire de l'art ou histoire sainte?" in *Les Cahiers du Musee national d'art moderne,* Centre Pompidou, Paris, 1987.
 "Father the Void" first appeared in *The New Necessity,* First Tyne International, Newcastle, 1990.
 Lines from *The Collected Poems of Wallace Stevens,* copyright 1954 by Wallace Stevens, are reprinted by permission of Alfred A. Knopf Inc.
The paper used in this publication meets the minimum requirements of American National Standard for Information Sciences—Permanence of Paper for Printed Library Materials.

CONTENTS

Art & Discontent

Introduction

O nce an anthropologist went to India with a movie camera and filmed the Indian rope trick. The trick was performed by an old man and a boy, in front of a crowd that gathered on the street. The old man threw a rope into the air and it stayed there, upright, on end. Then the boy climbed up the rope and disappeared from sight. A moment later the old man took a scimitar in his hand and climbed up the rope behind him, also disappearing from sight. Sounds of hacking and crying were heard, and the dismembered, bloody limbs of the boy fell to the ground one by one. The old man reappeared, climbed down, took the bloody limbs, and threw them into the air, where they disappeared from sight. In a moment the boy reappeared whole and healthy, and climbed down the rope. The anthropologist who had been filming the event watched it through the viewfinder. He saw it happen as described here, and so did everyone else in the crowd. But when he developed the film, it showed something else. What the camera saw was that the old man threw the rope into the air, the rope fell to earth, and the old man and the boy stood next to it for about ten minutes.

If we wish to interpret this story as an allegory of
the art system, we might say that the rope trick is the
artwork, with auratic claims of magical potency
clinging around it; the anthropologist is the credu-
lous viewer, eyes clouded by reverence for magic;
and the camera is criticism, working to blow away
the nimbus from the event and see it as integral to
real life rather than as a visitation from another
world. This is not to claim that criticism can attain
the completely projection-free objectivity attributed,
somewhat wishfully, to the camera in the parable,
but that it should work in that direction. Nor is it to
say that the artwork is a fake—only that it is vulner-
able to faked claims and concealed religious projec-
tions, which it is a part of the critic's role to clear
away. Sir Karl Popper said that the scientific method
means criticizing *everything*. Nietzsche said the es-
sence of philosophy was the detection of false claims.
The parable presents a model of the art world as a
communications system in which criticism is a de-
vice to detect false claims. Imagine a communica-
tions system with no built-in device to detect false
claims. It would be Madison Avenue without the
truth-in-advertising laws. Today we have a special
need to beware of that.

During the first late Abstract Expressionist era (to-
day being a kind of left-handed, hybrid second one)
the role of the critic, typified above all by Clement
Greenberg, was understood as that of quality con-
troller. A critical consensus had solidified around the
view that aesthetic canons were in some way objec-

tive. The market was lubricated by the palpable sense of aura that went with the hidden Platonism of it all. Establishmentarian collusion went so far as to involve the United States government in decisions about exhibitions and to embroil the art activity in international political ends. The criticism of the day, with its emphasis on pure form and severe denigration of subject matter, was enthusiastically vulnerable to such manipulation.

Artistic quality was understood at that time not merely as a display of skill, insight, talent, and dedication—but, really, as a display of magic. The aura of the supernatural heated the flow of money as once before it had inspired in those with wealth an intense desire for the relics of saints. Aura, of course, is a religious concept. It is based on a belief in Soul and its access to supernatural experiences, a belief not necessarily acknowledged by the critics. It has perpetuated in the 20th century the Neoplatonic myth that artworks are traces of the Soul's adventures in pursuit of the sublime. Unlike the reproduction (as Walter Benjamin pointed out), the original artwork was regarded, under the spell of the concept of aura, as a palpable trace of the activity of Soul. Like the icons described by the Neoplatonic occultist Porphyry, auratic artworks were regarded as retuned from the natural key (matter) to the supernatural (Spirit). An essentially religious reverence for aura was presupposed with more or less openness by both the great artworks and the great critical writings of the Modernist period. The intense reverence for the

original masterpiece was based on it. The great achievements of formalist criticism were based on it too.

The belief that transcendental insights or experiences can be achieved through art has as its dark alter ego or negative implication the belief that art has nothing to do with socio-economic realities. Untouched by them, it does not touch them either. Like the Eucharist, art is uncontaminated by the here below. It lies in the net of economic realities and yet is free of them, since its essence transcends contingencies and such things are merely contingent. As Clive Bell said, its work is not of this world. It has the same relation to worldly things as do prayer, meditation, and pious works. It takes place, like the ecstasies of Simeon Stylites, on top of a pillar. Art became a kind of church, especially in the late 1950s, when it functioned as a counterweight to a widely disparaged rationalism. Spurred on by the prophets (critics), the faithful (collectors) gathered the relics of the saints (artists) under the auspices of the proprietors of the church (dealers). In terms of the market, this was a kind of Golden Age. The opiate was distilled, bottled in fine decanters, on sale, and in demand.

But Golden Ages end: in their very purity lies the seed of their fall. All that had been forcibly excluded from the sacrament during the period of consensus broke out in heretical directions. From formalism grew Minimalism, and from Minimalism, conceptualism. Pluralism—which is the lack of critical consensus—was not far behind.

Beginning in the mid '60s and continuing through

the '70s, the formalist hegemony was challenged by a new model of the artist's and critic's roles. Under the influence of Walter Benjamin, Theodor Adorno, and other European thinkers in the Marxist tradition, some critics came to see their role not as greasing the market but as obstructing it. Seeking to lay bare the basis of the old power structure (which was weakened but by no means driven from the field), and at the same time, whether by design or not, solidifying a new one, these critics began to point to the socioeconomic net surrounding the canvas as well as to the nest of aesthetic forces operating within it. The critic's role was redefined from quality controller to radical conscience.

Similarly, many artists in the '60s and '70s devoted themselves explicitly to finding art modes that would slip off projections of aura and bypass the process of commodification. The critical project had gained such ascendancy that its methods became a new art material. Artists themselves began to take over the critical function, embodying it in artworks as well as essays. The objectivity of aesthetic judgments became the joke of the day (except in many university art departments). The beautiful began to smell of promotional sham. Traditional types of skill and talent were regarded as preoccupations for students, or worse.

But Iron Ages end, too: longing for the Golden Age becomes too intense. In the '60s and '70s many members of the art system and of the art public felt confused by the new hypercritical mode and cheated of the soul-sustaining belief in aura. The arts of the

new dispensation—conceptual art, performance art, site specificity—by and large produced few icons to elevate the spirit, emphasizing instead an aesthetic of wit, process, context, and analysis of consciousness. They deliberately frustrated the habit of emotional gratification attained through appreciation of aura and beauty. Among the faithful, though, the force of this habit could not easily be redirected into the new, cooler modes. Some formalist critics came to feel that the game, under the new rules, was not worth playing. Hesiod's lament was heard throughout the land: that he wished he had either been born earlier, when the Golden Age was here—or later, when it would have come back.

This crisis forced movement, and the outlines of a strategy for reconstituting, or seeming to reconstitute, the Golden Age of aesthetic aura began to emerge—a strategy not preconceived in any cabal, but as instinctively known in the flesh and nerves of the market as any animal's instinct for self-preservation. Simultaneously, around 1980, the international market situation was further stressed and complicated by resistance to American hegemony and the influx first of Italian and then in the following year of German neo-figurative painting. In the sensual delight of new aesthetic objects, and amid an increasing cultural amnesia, the socially-oriented critical style began to seem obfuscated and archaic; a new focus of the ear heard it as distant, ungratifying, puritanical. Those who opposed commodification could simply be bypassed. There followed a renascence of the easily commodifiable types of art objects, which

were received with a spotty understanding of the conceptual basis from which much of the new work, both European and American, had originated. A lot of the new figuration was first undertaken with a sense of the historical and semiotic ironies involved; soon this sense was transformed into an old-style enthusiasm for painting. In the general confusion, even older figurative painters whose works had different roots were received as embodying the new spirit. Many critics of the old formalist dispensation took heart. Expressions of delight were heard at the return of "skill"; attempts were made to dismiss the '60s and '70s as a period of disorientation. This mood was epitomized by French curator Jean Clair's declaration that whenever art is sick—as, he says, it was sickened with sensationalism in the '60s and '70s—it must return to its ultimate discipline, "drawing," for the cure.

The discovery of new artists became the keynote of the moment, and one began to hear that an Age of the Dealer had arrived. But this formulation is as inadequate as the assumption that all critics oppose commodification and all dealers promote it. The art system is not a power duel between critics and dealers but a complex interaction among several interlocking roles. When the system is healthy, artists first, then critics, dealers, collectors, curators, and the museums they curate, must be working both independently and interdependently. Lately, however, due to rapid shifts of evaluation in the accelerating pace of events and increasing imbalances in the flow of money—overheated here and underheated

there—an Age of Confusion threatens. Some crucial parts of the system have become virtually moribund—the major established museums in New York, for example—while others are drifting confusedly into one another's territories, their boundaries blurred. The contemporary curatorial establishment has drifted away from the task of discovering, exhibiting, and evaluating new art; in response to this shift, critics and dealers have begun to take up the slack, slipping into essentially curatorial activities. The most intimate knowledge of the contemporary scene and the most creative shapings and formulations of it have for several years been found in the galleries of enthusiastic and ambitious dealers, often assisted by hired critics, rather than in museum exhibitions. Many critics have taken up the curatorial function, some for museums eager for in-house defense systems, though most for galleries and alternative spaces who want to make sure at least one critic will stand behind the show. Several critics have become gallery managers.

The obvious dangers lurking in this situation are accentuated by the enormous expansion that the art system as a whole has undergone in recent years. Careers created by market forces can be replaced as easily as parts in a cash register. A whole movement can be called up in an instant from the loam of the thousands of eager and talented young artists and then replaced by another one before the season is out. The problem is no longer that artworks will end up as commodities, but that they will start out as such. Expanded scale and intensified pace have cast

over the art arena a veneer of glamor that further imbalances it all. Serious collectors, for example, who acquire with the care and acumen of dedicated professionals, are confronted with the economic challenge of hundreds of amateur or pseudo-collectors who, under the spell of fashion, will buy just enough to decorate their living rooms, meanwhile driving up prices out of reason. Similarly the uncritical inflation of reputations by amateur or pseudo-critics caught up in the search for the young, the new, the next, further muddles the situation.

The problem with all this is that an Age of Confusion can easily turn into a Dark Age. And when the possibility of a Dark Age looms, the factor that is most crucial in determining whether or not it comes about is the presence or absence of critical consciousness in the fullest sense. Obviously the critic must act as more than a barometric reflection of the market. But the role of the critic as social conscience riding herd on a market situation is inadequate also. And the model of quality controller, or arbiter of taste, is inadequate as well—though this has become our most commonly accepted mode. Detection of the spurious *does* involve appreciation of the authentic. But the relationship of criticism to money and power goes beyond that: it is about freedom.

The cultural contribution of critical consciousness, from Sextus Empiricus in the 2nd century AD to Jacques Derrida in the 20th, has been to see that no model of reality gets such a hold on our minds as to seem exclusively true and become a dogma. This contribution necessarily brings the critical tradition

into an intensely antagonistic relationship to author-
ity. Dogmas support ruling groups (as the dogma
of aesthetic formalism for years sustained a ruling
clique in art criticism). Dogmas are expressions of
the will to power, since by enforcing conceptual clo-
sure on reality one appropriates it and all within it.
They bear the most intimate relationship to authority
in general, which, when its dogmas fail, must resort
to coercion by brute force. Criticism, then, as the
gadfly of dogma, is the perennial challenge to
authority, and is perennially vulnerable to forcible
repression. Attempts to co-opt the critical function
into soft, safe uses are, ultimately, attempts to clear
the way for some absolute power. The history of
Western culture is marked by the continuing struggle
between the forces of dogma, supporting claims for
authority, and of criticism, undermining them.

It is in the records of the Greek democracies that
the critical consciousness can first be seen with clarity
as a public force, and indeed criticism can be said to
have a special relationship to democracy, which is its
political expression, as tyranny is the political ex-
pression of dogma. Socrates, that gadfly crushed by
the force of authority for embodying the critical
function as a necessary part of public sanity, is the
first recorded martyr of the critical attitude. In me-
dieval Europe there were thousands more, as the re-
lation between authority and criticism was expressed
in the faith/reason controversy and its executive
branch, the Inquisition. Peter Abelard had only to
raise the question of the Trinity (just *how* could He
be both three and one?) to have his book burned and

be excluded from teaching. The power of inquiry to undermine dogma was too well understood to be tolerated. The long and dreadful story of the Inquisition, the closing of the universities by terrified dogmatic authorities, the benighting of Europe in the name of faith, or anti-reason, suggests that our heritage has a special problem with dogma and must be specially alert to threats against the critical spirit. In Islam also the crushing of the critical spirit of Averroism inaugurated centuries of fanatical ignorance and the downfall of a brilliant and creative culture. Both in Islam and in fundamentalist Christianity, the critical attitude came to be understood as a temptation devised by Satan, to ensnare humanity by its pride in intellect. There is no ambiguity in this structure. Popper's perception that science is one with criticism is equally unambiguous. Dogma is the absolute and unrelenting enemy of science, and the entire disagreement between them is over the status of critical thought.

Recurrences of the faith/reason controversy have been and remain a characteristic feature of Western culture. The 18th century replayed it, but with a different outcome. Voltaire's aim "to crush the infamous thing" (*ecraser l'infame*) was aimed specifically against dogma as embodied in the church. But it is most interesting that in this same century—which saw an overpowering advance of critical thought in the work of David Hume, Voltaire, and others— the religious structures no longer tolerated in broader cultural arenas were first concealed within a theory of aesthetics. This was accomplished by the Earl of

Shaftesbury, under the influence of the reactionary enclave known as the Cambridge Platonists. Historically, in other words, the perception of aura, with its hidden presupposition of unchanging Soul, is the same "infamous thing" that Voltaire wished coincidentally to crush in the 18th century. Shaftesbury's concept of artistic "disinterestedness" is the origin of Clive Bell's dictum that the kingdom of art is not of this world. Kant's insistence (following on Shaftesbury) that there is an autonomous aesthetic faculty, not subject to the control of the cognitive or practical faculties, was again the concealment of Soul, its secretive reintroduction into a world from which Humian analysis had dismissed it.

Friedrich Schelling's elevation of this "aesthetic faculty" to the highest place among the human faculties merely underlines the fact: from the Earl of Shaftesbury to Greenberg the worship of a faculty of taste is a disguised form of the Platonic doctrine of unchanging Soul, which the rational and scientific culture of the Enlightenment had relegated to the periphery of practical affairs, that is, to the realm of art. Claims of Soul are claims of essence: they postulate reality as fixed and unchanging in its central meanings and intentions. Rejections of change in turn function as buttresses to existing power structures. They are the hallmark of the Egyptianism or Platonism that informs absolute tyrannies everywhere. Democracy, as Popper noted, is dedicated to the principle of rational change, which means that it is devoted to the principle of criticism. It is no accident that when Adolf Hitler wanted to bring art to

heel and eliminate it as a force for social change, he attacked the critics as well as the artists. For it is only through critical consciousness that rational change occurs, and dogma, whether aesthetic or political, is its ultimate enemy.

When Popper, the great philosopher of science, said that the scientific attitude means criticizing *every*thing, he pointed to criticism as the force that enables civilization to advance. When Nietzsche said, in the *Twilight of the Gods* (1889), that the trained ability to detect the spurious was the beginning of philosophy, he meant that a critical attitude was the foundation of reason. These things are as true in the realm of art as in those of philosophy or politics.

Heads It's Form,
Tails It's Not Content

*It has rightly been said that theory, if not received at the
door of an empirical discipline, comes in through the
chimney like a ghost and upsets the furniture.*
—*Erwin Panofsky*[1]

P assionate belief systems pass through cultures
like disease epidemics. The great formalist criti-
cal tradition of the postwar period, embodied in the
works of Clement Greenberg, Michael Fried, Shel-
don Nodelman, and others, still has the art body in
the last shivers of its fever. In their practice these
critics opened the artwork to profound phe-
nomenological analyses. But their concern with sur-
face, figure, and color eventually coagulated into a
repressive ideology that could allow no real theoreti-
cal discussion of the inspired practice, which seemed
as given as life itself. It is time to reconsider certain
basic questions that, from a formalist viewpoint,
have long been regarded as closed.

*One of the characteristics of myths is that they seem
to promise rules of order but never deliver them.*
—*Jack Burnham*[2]

Foremost, of course, is the problem of content. As the formalist approach to this problem, Rosalind Krauss presents the critic's perception of "feeling" in a work: "The experience of a work of art is always in part about the thoughts and feelings that have elicited—or more than that, entailed—the making of the work. And if the work is not a vehicle of those emotions, in no matter how surprising a form, then what one is in the presence of is not art but design."[3] To illustrate this strategy Krauss quotes Michael Fried: "Both [Kenneth] Noland and [Jules] Olitski are primarily painters of *feeling,* and ... their preeminence ... chiefly resides not in the formal intelligence of their work ... but in the depth and sweep of feeling which this intelligence makes possible."[4] The implication is that when a critic ascribes "feeling" to an artist's work the critic is dealing adequately—or at least as far as decency allows—with the problem of content. Indeed, one's sense of decency is the question; formalist writers often have spoken against content with a moralist intensity.

But what exactly does this word "feeling" mean? Krauss glosses the term once as "thoughts and feelings" and again as "emotions." Fried, similarly, calls Noland's paintings "powerful emotional statements" and ascribes "passion," "emotion," and "expressive freedom" to them. Yet in neither Fried's nor Krauss' essay will one find mention of any deciphered "thoughts" or specified "emotions," or indeed any mention at all of what it is that is "expressed." As Alan Tormey has noted, this view "does not establish a relevant distinction between art and any other

form of human activity."[5] In fact, it seems that the word "feeling" is practically a verbal blank. To qualify the blank, as Fried does, as "the depth and sweep of feeling," is simply to expand it.[6]

> *Irving Sandler and Robert A.M. Stern had a fight in our loft early this year . . . "I didn't see any content in [Mark Rothko's] pictures," said Stern. . . . Sandler . . . replied that content in Rothko's paintings is expressed in color, form, facture. Stern said that content requires a reference to the world outside . . . "Painting is color and light," counterpunched Sandler. "If nothing else, these paintings are about painting."—Douglas Davis [7]*

When Fried ascribes "feeling" to the works of No-land and Olitski, while maintaining that these artists address themselves "to eyesight alone" and that their works are of a "purely visual nature,"[8] he is laboring under the difficult burden of Clement Greenberg's theory. Greenberg maintained that "visual art should confine itself exclusively to what is given in visual experience and make no reference to anything given in other orders of experience."[9] Content, he believed, must become "strictly optical" and "be dissolved . . . completely into form."[10] When Greenberg faced the question (which stymied both Plato and Aristotle) of how a form can be experienced without a content, he took the position, enunciated previously by Benedetto Croce and others, that content is an aspect of form. The painting's "quality," he declared (a matter of formal considerations), *is* its content.[11] This attitude, however valuable as a declaration of faith, should not be mistaken for rational

thinking. Of course, at the time Greenberg was writing, many people would have agreed with him. Illogic often grips small power groups that feel they have history by the neck.

> *The basic requirement of this ideology is that no meaning*
> *of any kind can be allowed to pollute visual integrity.*
> *—Douglas Davis*[12]

The impossible idea of pure form (form without content) quickly became an absolute. With the zeal of devotees, Greenberg, Fried, Susan Sontag, and others attempted to purify art of significations, whether by eliminating them from the viewer's awareness, by neutralizing them (as with, for example, blank "feeling"), or by enclosing them in a hermetic athanor of self-reference.

> *Poetry is the subject of the poem.*
> *From this the poem issues and*
> *To this returns. Between the two.*
> *Between issue and return, there is*
> *An absence in reality.*
> *Things as they are.*
> *Or so we say.*
>
> *—Wallace Stevens, "The Man with the Blue Guitar"*

This project is rooted in the Romantic tradition (and behind it in Neoplatonism), which yearned to see the artwork as transcendentally free, beyond the web of conditionality. Spurred on by the desire for the sacred in a secular age, the enterprise took on a quasi-religious aura, and by the mid-'60s Greenberg,

Sontag, and the rest were preaching to the converted. By then, formalist theory was an accepted myth. In the Levi-Straussian sense a myth is a device to mediate between culture and nature, either by naturalizing culture or by culturizing nature; in this case, the mythifying tactic was to naturalize culture. Artworks were to be granted a self-validating status like that of objects of nature such as stones or leaves, which are not asked to refer, to signify, or to justify themselves in any external terms. Nothing was left to the artwork except pure sensory presence, with no concepts, no signification, no relationship to anything outside itself.

If the faces on Mt. Rushmore were the effect of the action of wind and rain, our relation to them would be very different.—Frank Cioffi[13]

"The avant-garde poet or artist," Greenberg wrote, "tries in effect to imitate God by creating something valid solely on its own terms, in the way nature itself is valid, in the way a landscape—not its picture—is esthetically valid, something given, increate, independent of meanings, similars or originals."[14] That Greenberg's diction in this passage is an essentially theological diction of absolutism was perhaps not obvious when the words were written. But it should by now be clear that here we are dealing with a cultural prejudice that, like many others, has tried to disguise itself as a natural law. The technique of the disguise is to promote a kind of selective seeing: filters are overlaid on the cognitive processes

to screen out significations—or rather, to screen out signifieds, the plane of content, and to focus exclusively on the emptied signifiers, the plane of expression (or form).

But the claim for the autonomy of the plane of expression, for its freedom from any plane of content whatever, is a contradiction in terms. As Ferdinand de Saussure made clear, "Though we may speak of signifier and signified as if they were separate entities, they exist only as components of the sign."[15] Similarly, Claude Levi-Strauss denounced Russian formalism for neglecting "the complementarity of signifier and signified."[16] "For [formalism] the two domains [form and content] must be absolutely separate, since form alone is intelligible and content is only a residual deprived of any significant value. For structuralism, this opposition does not exist.... Form and content are of the same nature, susceptible to the same analysis."[17]

And the portrait show seems to have no faces in it at all,
 just paint
you suddenly wonder why in the world anyone ever did
 them
 —Frank O'Hara, "Having a coke with you"

For God's sake, do not explain that picture
of the bright-haired girl on a diamond black horse
 ... These realities
of delight and beauty at their imperfect source
are indiscreet, if not indecent, subjects for any lecture.

 —Horace Gregory, "Daemon and Lectern
 and a Life-Size Mirror"

In the attempt to free art from the plane of content, the formalist tradition denied that elements of the artwork may refer outside the work toward the embracing world. Rather, the elements are to be understood as referring to one another inside the work, in an interior and self-subsistent aesthetic code. The claim is imprecisely and incompletely made, however, because the formalists take much too narrow a view of what can constitute "content." Greenberg, for example, often uses the term "non-representational" to describe "pure" artworks—those purified of the world. But as he uses it, the term seems to rule out only clear representations of physical objects such as chairs, bowls of fruit, or naked figures lying on couches. Similarly, Fried assumes that only "recognizable objects, persons, and places" can provide the content of a painting.[18] But art that is non-representational in this sense may still be representational in others. It may be bound to the surrounding world by its reflection of structures of thought, political tensions, psychological attitudes, and so forth.

> *[Pollock's] pictures leave us dazzled before the imponderables of galaxy and atom.* —Robert Rosenblum[19]

> *Pollock's field is optical because it addresses itself to eyesight alone.* —Michael Fried[20]

Jackson Pollock is one of Greenberg's prime examples of an artist whose work is supposedly "pure," without semantic function. But an interestingly different approach is suggested in Joseph Campbell's

The Mythic Image, where Pollock's *Autumn Rhythm* is reproduced alongside a passage from the Buddhist Prajnaparamita literature: "Like stars, like darkness, like a lamp, a phantom, dew, bubbles, a dream, a flash of lighning, and a cloud—this is how we should look upon the world."[21] Campbell, in other words, reads *Autumn Rhythm* as a cosmological diagram of flux and indeterminacy, as at times Pollock himself seems to have done.

> *Can art evoke emotions without recalling images?*
> *—Nicolas Calas*[22]

Piet Mondrian, of course, was Greenberg's foremost example of an artist whose work is set over against the "extra-pictorial references of old time illusionist art." In effect, Mondrian was his proof of radical formalism: "Mondrian . . . has shown us that the pictorial can remain pictorial when every trace or suggestion of the representational has been eliminated."[23] But of course Mondrian was not the first to demonstrate that art can survive without representing "recognizable objects, persons, and places"; he was preceded by the abstract artists of the Paleolithic, Neolithic, and Bronze Ages and by later Tantric and Islamic artists who eliminated this type of representation in favor of abstract quadrature, heraldic symmetry, monochromy, and so forth. In fact, abstract painting is a practice that precedes our species; the earliest known examples are Neanderthal finger-paintings. This historical quibble is important because it points to a significant set of omissions in

the Greenbergian argument—and the reason for the omissions is not far to seek: in these older traditions, content was read comfortably from abstract form. The works produced by these pre-modern abstract artists are widely interpreted as representing ideas about the nature of the universe. They are art as "a way of *thinking about reality,*" in William Wilson's words.[24] They present two-dimensional models or schematic diagrams of the real; to call them diagrams of consciousness as then experienced, without altering the facts, would bring them into a more phenomenological framework. While non-representational in terms of physical objects, these works have clear metaphysical or cosmological content.

Since Wittgenstein has described the proposition as an "image of reality," the image could be viewed as a proposition about reality.—*Nicolas Calas*[25]

In much the same way, Mondrian's mature paintings can be read as presenting a model of the real: they suggest a geometrically ordered universe made up of a few unchanging and universal elements which shift their arrangements to create the impression of changing particulars. The right angles signify mathematical consistency and rigor; the three primary colors hint at a small number of abstract building blocks; the sense of construction in the interlaced verticals and horizontals suggests the orderly underpinnings of the chaotic universe of experience.[26] Plato's *Timaeus* might be used as an accompanying text, just as Campbell juxtaposes the Pollock with a Prajnaparamita passage.

Furthermore, a blue monochrome by Yves Klein might be juxtaposed with any number of texts on philosophical monism, from Parmenides to Sankara and beyond. Analogizing the alchemical notion of Prime Matter, Klein shows plurality totally absorbed within unity, which is viewed as the unchanging substrate of changing experience.[27] Clearly, the work of these three painters—which must be non-representational or without content in Greenberg's view—may be regarded as representative of basic metaphysical tendencies that constitute a type of content. Pollock models reality as indefinite and in perpetual flux; Klein presents a counterview of reality as unified and fundamentally static; Mondrian suggests a middle view of reality as stable in its elements but changing in its surface configurations. Greenberg himself was approaching something like this view in the essay titled "On the Role of Nature in Modernist Painting,"[28] but he did not, indeed he could not, integrate it into his "purely optical" theory.

Now, the formalist would say that we needn't know [Courbet's politics] to respond to [his] painting. . . . But mid-nineteenth century viewers of these paintings did see their political qualities, which I contend are fused into the visual context of the work: they are not "literary."
—Douglas Davis[29]

Marxist critics have insisted that any act (including any art act) is saturated with political meaning. Philosophers have argued similarly that any act is saturated with philosophical meaning. Each act is

grounded in a subtext of implied assumptions about the nature of reality. The experiencing of a work of art, then, is not merely a matter of aesthetic taste; it is also a matter of reacting to a proposition about the nature of reality that is implicitly or explicitly shadowed forth in the work. As Wilson remarks: "That hypothesis—that a work of art is a proposal about what is real—might help to explain why art that people don't like makes them so angry."[30]

> *[Barnett] Newman's best paintings address themselves*
> *to eyesight alone . . . They seek to create . . . an experi-*
> *ence of spatiality that is purely and exclusively visual.*
> *—Michael Fried[31]*

> *Why these long, provocative titles and dedications?*
> *Behind them is a mind and a sensibility frustrated by*
> *the dogmas of anti-content.—Douglas Davis[32]*

Once we have realized that the plane of content can contain much more than "recognizable objects, persons, and place," we must peer more shrewdly at the context of the work and cock a more attentive ear to the artists' own statements. When Harold Rosenberg wrote that "paintings are today apprehended with the ears"[33] he was revising Greenberg's entirely-through-the-eyes approach and pointing to the plain fact that verbal supplements are of crucial importance in relating to art. Marcel Duchamp may have had the same point in mind when he remarked that the most important thing about a painting is its title.

It is important to realize that the formalists' claim that such verbal indicators are not relevant is highly suspect in terms of their own practice. For example, Rosenberg points out that without Newman's cabalistic titles and writings we would be unable to distinguish his work with certainty from "Bauhaus design or mathematical abstraction."[34] Yet formalist critics do make that distinction—and not only since Thomas Hess' (in)famous catalogue essay laying bare the cabalistic roots of Newman's verbal supplements. Even Greenberg did so, saying, "Newman's art has nothing whatsoever to do with Mondrian's, Maelvich's or anything else in geometrical abstraction."[35] Greenberg refers to Newman's work as "an activated pregnant 'emptiness' "[36]: the phrase is virtually a quotation from Gershom Scholem's paraphrases of the cabalistic texts, which Newman admired, and the quotation marks around "emptiness" suggest that the word refers to some literary notion, not merely to the lack of a figure on the ground. In short, "activated pregnant 'emptiness' " is a description of Newman's content quite as much as of his form.

> Historians clearly recognize the metaphysical implications of art prior to the modern era, but they are remarkably ingenious in avoiding a confrontation with the metaphysical suppositions of contemporary art.
> —Jack Burnham[37]

Ad Reinhardt also belonged to what Rosenberg called the metaphysical branch of abstract expres-

sionism. Yet the artist's own statements about the metaphysical intentions of his works have been largely screened out by the formalist filter. Reinhardt's writings contain clear allusions to the locutions of Buddhist texts and echoes of T'ang-dynasty Taoist painting manuals. His reductionism was in part an attempt to express the Taoist/Buddhist doctrine of the absolute as dynamic emptiness. Critics seeking the content of his work should look neither to the Greek Christian cross nor to the problem of the surface, but to the four-limbed mandalas of the Orient—especially the Taoist mandala of 64 squares, which is virtually identical to the internal quadrature of Reinhardt's paintings.[38] That this is a traditional icon, bringing a weight of metaphysical content with it (unless the artist deliberately empties it out), is beyond doubt.

The new movement is, with the majority of painters, essentially a religious movement.—Harold Rosenberg[39]

Finally one must wonder whether Reinhardt's and many related works are better read as mere sensory presences or as metaphysical statements like those of Tantric and other abstract allegories. They could be hung in the manner of icons in a church as readily as in the manner of pictures in a gallery. They are saturated with content, and the refusal to see it, the insistence on screening it out of our experience, is a kind of aggression against the work and against the artists themselves.

> *The esthetic or artistic is an ultimate, intrinsic value, an*
> *end-value, one that leads to nothing beyond itself. . . .*
> *Knowledge and wisdom can funnel into, can serve, the*
> *esthetic, but the esthetic—like the ethical or moral in the*
> *end—can't serve anything but itself.*
> —*Clement Greenberg*[40]

In a sense, the metaphysical quality of much abstract work is recognized, somewhat covertly, by formalist critics. At one moment Greenberg restricts the artwork to purely optical qualities; at another, sliding into theological diction, he speaks of art-for-art's-sake as a kind of absolute, with hidden transcendental implications. The discrepancy between emphasis on the optical surface on the one hand and implications of transcendental status on the other seems to trouble even today's leading formalists. Sheldon Nodelman, for example, attempts to carry the burden of the "purely optical" doctrine while opening wider those transcendental avenues hinted at by Greenberg's hidden theologizing. In doing so, he lays bare an irrational implication that underlies many statements of the formalist position.

In an article in the *Yale Architectural Journal*, Nodelman first nods to formalist orthodoxy by speaking of "the intense opticality of sixties' art" which has left "no residuum of content."[41] Then he attempts to overleap the limitations of this very doctrine. Color, he says, "addresses itself, through the visual sense, not mediately toward the physical apparatus with which the body moves and contends in the world, but immediately toward the higher centers

of consciousness: it is the most 'spiritual' of all sensory qualities."[42] He is saying, in other words: (1) that color, while a sensory quality, bypasses the body system—an obvious contradiction in terms; (2) that it bypasses also the conceptual mind—a thing impossible to prove and unlikely in any modern view of human psychology, and (3) that it works on some undefined "higher center of consciousness" in a "spiritual" way.

The doctrine that color addresses "higher centers" stems from 19th-century occultism (Madame Blavatsky, et al.), and is brought into formalist theory as a thinly disguised deus ex machina to fill the blank left by the annihilation of content. If all color inherently addresses "higher centers," then one might as profitably behold a colored wall as a painting hung on it, or one painting as well as another. If, on the other hand, the color presented by Morris Louis and Frank Stella (whom Nodelman is discussing here) has a special ability to reach those "higher centers," then wherein does this ability reside? Does their particular avoidance of any suggestion of figure and ground amount, as Nodelman implies, to a spiritual substance mixed in the paint? Shall we take the formalist critic's word that he or she perceives this spiritual substance, though we may not? This seems the procedure of a mystery cult or oracle, and Nodelman, in referring to non-sensory "higher centers," speaks like an initiate of the astral plane. The birth of the art experience turns out to be a kind of virgin birth, bypassing both the body and the conceptual mind, and whispering its message directly into the ear of

the critic's soul, like the angel at the Annunciation. This is not rational criticism; Nodelman's retreat from the limitations of the "purely optical" doctrine at the same time that he is espousing it suggests an illicit yearning for content.

> *Do we itch for Content—for Meaning—when we see a blank tablet? Yes, yes, yes, yes, yes. We're itching now, more than ever. Hear me scratching? I can hear you.*
> —*Douglas Davis*[43]

In fact, much interpretation masquerades as description, and much avowedly formalist criticism contains hidden references that can't escape content. Of course, if the critic must speak, then his or her thought must be qualified by the nature of language. But when Fried, for example, speaks of the "tortured" space of Willem de Kooning's paintings, when David Sylvester calls Henry Moore's work "organic," when Nodelman speaks of "forces and energies" on the canvas, these critics are moving further into covert interpretations than descriptive language requires.

> *The avant-garde poet or artist sought to maintain a high level of his art by both narrowing and raising it to the expression of an absolute.... "Art for art's sake" and "pure poetry" appeared, and subject matter or content became something to be avoided like the plague.*
> —*Clement Greenberg*[44]

The formalist myth has fed repeatedly on a kind of pre-logical incantation masquerading as reason.

This is most obvious in the widespread cult slogan of "art for art's sake." Ad Reinhardt's writings, for example—which are often mentioned with approval by formalist critics—vacillate cunningly between radical formalism and metaphysical absolutism (two codes, with shared Platonic backgrounds, which also mingle in the writings of Kasimir Malevich, Klein, Newman, and others). Reinhardt's locutions often seem to express the purist art-for-art's-sake attitude. "The one thing to say about art is that it is one thing. Art is art-as-art and everything else is everything else. As art art is nothing but art. Art is not what is not art." Joseph Kosuth, who quotes this statement approvingly, adds his own to the same effect: "Art indeed exists for its own sake. ... Art's only claim is for art. Art is the definition of art."[45] The problem with statements of this type is that they are meaningless when reduced to logical terms. When Reinhardt, for example, in his radical formalist mood, asserts that art is art and art is not not-art he seems to feel that he is stating a conclusion. But in terms of formal logic what he has stated is simply the Law of Identity—the principle that $A = A$ and $A \neq -A$ (A equals A and A does not equal not-A).

> *[If the Law of Identity is not assumed] then it is evident that there would be no discourse; for not to have some specific meaning is to have no meaning, and when words have no meaning, conversation with another, or even with oneself, has been annihilated, since it is impossible for one who does not think something to think anything.—Aristotle[46]*

The Law of Identity applies equally and alike to all things in the realm of discourse. Everything, insofar as it is anything, is itself and not not-itself. The application of the principle to art, in other words, does not in the least constitute a claim to special status. On the contrary, it demonstrates that art exists on the same ontological footing as anything else.

Reinhardt, Kosuth, and others who have made statements of this type have misunderstood an underlying ground rule for a reasoned conclusion of thought. The error might be paralleled by mistaking the axioms of Euclidean geometry for its conclusions. Recognition of the Law of Identity does not mean that we have come to the end of a line of reasoned thought, but that we are now ready to begin thinking.[47]

Kosuth compounds the problem by confusing the Law of Identity with an analytic proposition or tautology: " ... Art is analogous to an analytic proposition, and ... it is art's existence as a tautology that enables art to remain 'aloof' from philosophical presumptions."[48] This approach is a kind of closet formalism and shares formalism's logical weaknesses.[49] Kosuth seems to mean no more than that art is art— the Law of Identity again. Like the ascription of "feeling," such statements are universal blanks. Again, thought does not culminate in such an assertion, but begins with it.

Whatever it may have been in the past, the idea of content is today mainly a hindrance, a nuisance, a subtle or not so subtle philistinism.—Susan Sontag[50]

Formalist doctrine finds its extreme expression in Susan Sontag's influential essays from the mid-'60s, which encapsulate conveniently the logical problems of formalism. Among the points Sontag argues are the following:

(1) "Interpretation is the revenge of the intellect upon art."[51] But the view that the intellect is either uninvolved in or antagonistic to art—that "in order to feed a thought you must starve a sensation," as the poet Marv Friedenn has written—can only serve to make art incomprehensible to intelligent beings.[52]

(2) "It is possible to elude the interpreters . . . by making works of art . . . whose address is so direct that the work can be . . . just what it is."[53] This statement begs the question, because "just what it is" has not been established yet. Furthermore, it is simply a restatement of the Law of Identity again. The work already is just what it is (how could it be anything else?), and this fact does not in the least take it out of the range of relationship, worldliness, and interpretation.

(3) "The function of criticism should be to show *how it is what it is*, even *that it is what it is*, rather than to show *what it means*."[54] Here again is the mythifying tactic of naturalizing culture. Perhaps a stone can be without meaning, but it is very doubtful that any cultural object, being a product of human consciousness with its intricate weavings, can exist except in a web of intentions and meanings.

(4) "It is the habit of approaching works of art in order to *interpret* them that sustains the fancy that

there really is such a thing as the content of a work of art."[55] Above all, Sontag carries to an extreme the formalist doctrine that the plane of content must be abolished by absorbing it into the plane of form. In fact, she states that the distinction between form and content is "an illusion."[56]

The question is what one means by *distinction*. The relation between form and content is one of universal concomitance; that is, neither of them ever appears without the other. The same relationship exists between many paired terms, such as cause and effect, up and down, right and left, and does not in the least mean that we cannot distinguish one from the other, but rather that the existence of one always implies the existence of the other. In fact, the attempt to absorb one of them into the other is self-defeating, because in the relationship of universal concomitance neither element can be self-sufficient or ontologically prior; each term of such a pair is dependent upon the other. Just as a cause can only exist as the cause of an effect, and an effect as the effect of a cause, so form can only exist as the form of a content, and content as the content of a form. The terms are distinguishable, though logically dependent on one another.

It is true that some artists choose to minimize one aspect or the other of the form/content tandem. In the work of the artists generally favored by formalist critics, content has often been minimized or blurred for the sake of the clarity and directness of form. In the work of Social Realists (as an example) formal values have been minimized, or rendered invisible

through commonplaceness, for the sake of content.

An accurate model of this situation would show a *hypothetical* pure form at one end of a bipolar continuum and a *hypothetical* pure content at the other. In between is an area where they fade progressively into one another. As in a fade between two colors, there is no precise point where one principle ends and the other begins, nor does either term ever exist to the absolute exclusion of the other: they are mixed in different ratios at different points on the continuum. Critics irrationally defeat their own purposes when they deny reality to one term for the greater glory of the other, since the one that is favored, being dependent on the one rejected, must lose reality along with it. In a sense, then, the dispute over form and content has no inherent reality, but is merely a dispute between those passionately dedicated to one aspect or the other.

> *If there be nothing besides the sensible, there would be no principle or order. . . . Real being is attributed in one way to the material, in another way to the form, and in a third, to their product.—Aristotle*[57]

Ultimately the idea that references and associations are to be excluded from the art experience is naive. Panofsky has opined that to perceive an artwork without "perceiving the relations of signification" would be the approach of an animal, not a human.[58] Obviously the art experience is conditioned heavily by what one knows, by what one has learned to expect, and by what one likes. To quote Panofsky

again, "the ... experience of a work of art depends
... not only on the natural sensitivity and visual
training of the spectator, but also on his cultural
equipment. There is no such thing as an entirely
'naive' beholder."[59]

> The big question here, of course, is whether it is possible
> to have aesthetic experience that is not culturally
> conditioned.—Donald Kuspit[60]

> In art description and nothing but description is
> unjustifiable because retinal images are automatically
> associated with cerebral images.—Nicolas Calas[61]

Jacques Lacan and Noam Chomsky have argued
in different ways that linguistic activities extend far
into the unconscious. Language seems to provide a
background stratum against which every mental and
perceptual event takes place. If this is correct, then it
is impossible that we could ever achieve a "purely
optical" experience of a work of art—and indeed that
idea may be a contradiction in terms. (Without con-
cepts, how do we know it is art?) Mental states in
which ordinary types of conceptualization are tem-
porarily suspended (such as those ensuing on long
meditation, or on the ingestion of certain drugs)
seem to be states in which all sensa are about equally
fascinating. The artwork as an unusually fascinating
or beautiful sensum may not exist outside a particu-
lar intellectual framework, and may not even be pos-
sible outside it.

The principle of excluding non-optical elements

from the work, then, is not a real principle. It *must* be compromised and, given the associative habit of the human mind, is *always* compromised. The question, then, is simply where to draw the line. Are the viewers' expectations in and the artists' intentions out? If so, why?

> *Do not enter this hotel with any intentions.*
> —*Sign over hotel desk in Aurangabad, India*

The heart of the form/content question is the question of the relevance of the artist's intentions, which, of course, formalism excludes as outside the physical work. This debate has been more fully argued among literary than among art critics: in fact, the formalist position seems in part transposed from the arena of literary debate. The so-called "New Critics" of an earlier generation (especially William Wimsatt and Monroe Beardsley) did for literature what Greenberg and others both before and after him[62] have done for the visual arts: they fostered a myth of the autonomy of the literary work, which "should not be judged by reference to criteria or considerations beyond itself."[63] To the New Critics a poem consisted not of referential statements about the world beyond it, but of "the presentation and sophisticated organization of a set of complex experiences in verbal form."[64] The emphasis on "experience," which must be apprehended by a non-conceptual aesthetic sense, brings us straight to the myth of the "pure" painting. Similarly the New Critics, like the Greenbergians, preached "a strenuous rejection of

the authority or relevance of an author's or artist's
intention on the grounds that the work of art is a
self-contained object accessible in some perceptually
fair sense to the objective appreciation of competent
agents."[65]

> *The conviction that a poet [or painter] stands in a certain*
> *relation to his words [or paintings] conditions our re-*
> *sponse to them . . . We are not ordinarily aware of this*
> *as these convictions tend to be held in solution "in the*
> *work itself." It is only in exceptional circumstances that*
> *we crystallize them as explicit beliefs and become aware*
> *of the role they play. Why should anyone wish*
> *to deny this?—Frank Cioffi[66]*

But in several ways it is clearly impossible to ex-
clude the artist's intentions from the critical process.
Krauss, for example, allows the critic to be aware of
"the sense of historical necessity" (that is, *art*-histori-
cal necessity) that brings a particular painting into
existence at a particular time. The critic, then, should
at least know the date (or the approximate date) of
the work, and this information is of course bio-
graphical and intentionalistic. Imagine yourself look-
ing at a painting in a gallery, by an artist whose
name is unknown to you, and reading its date, from
the wall label, as 1860; suddenly a gallery attendant
approaches and corrects the label to read 1960. One's
critical awareness shifts immediately in response to
one's new sense of what the artist knew, what paint-
ings the artist had seen, and what the artist's implicit
intentions, given his or her historical context, must
have been.

Even more basic is our awareness of the genre of the work. Is a white rectangle with marks on it being presented as a painting, a drawing, a poem, a news story, or something else? In each case one's sense of the work changes. Yet the genre classification is outside the physical work and constitutes, in effect, another appeal to the artist's intentions. We are asking, really whether the artist *intended* it as a painting, a poem, or whatever.

Other "outside" elements that all critics, even the most hardened formalists, make use of regularly are (1) allusions, which are based on the biographical assumption that the artist or author has seen certain paintings or read certain books; (2) the artist's reputation; and (3) the record of his or her earlier work. Clearly we use such facts because they indicate something of the artist's intentions. "If it [the poem or painting] had been written [or painted] by someone else," as Cioffi asks, "wouldn't this make a difference in our apprehension of it?"[67] Imagine the label switch again. You are looking at a painting attributed to Ellsworth Kelly when the label is corrected to read Barnett Newman. Hasn't your response to the work changed radically, too?

Where
Do I begin and end? And where.
As I strum the thing, do I pick up
That which momentarily declares
Itself not to be I and yet
Must be. It could be nothing else.

 —Wallace Stevens, "The Man with the Blue Guitar"

The question is not whether content is present, but what its relationship to form is. To use semiological terms: Is the form/content relationship *motivated*—that is, is the content inherent in the formal properties of the work—; or is it *unmotivated*—that is, is the content added from outside by the work's audience (including the artist)?

Formalist critics, bound to an essentially theological conviction that form is self-subsistent and absolute, have insisted that the impact of the visual surface of the work *is* its content. The formalist understandably fears a situation in which interpretation might run out of control and smother the visual life of the work beneath irrelevant intellectual overlays; if the form/content relationship is unmotivated a limitless number of possible interpretations exists, none more firmly bound to the physical object (the artwork) than any other. The process of interpretation, then, being uncontrollable to the point of randomness, should be avoided.

The alternative is a view like that which Edward Said expresses about literary texts, and which applies equally to visual ones. "Texts impose constraints and limits upon their interpretation . . . because as texts they *place* themselves . . . they *are* themselves by acting, in the world. Moreover, their manner of doing this is to place restraints upon what can be done with (and to) them interpretively."[68] Of course, to say that works place themselves within certain limits of interpretation is not to say that every viewer will experience the work with the same feeling-tone and

the same associations. The motivation of signifier and signified, when present at all, is partial, and responds both to cultural boundaries and personal sensibilities. Still, within these variable limits, some connections will be widely recognized as appropriate, others not. In representational art, for example, certain formal structures are read as chairs, others as bowls of fruit, others as naked figures lying on couches. The question is whether this relationship can be extended to clearly connect abstract forms and non-physical things such as thoughts, emotions, and structures of ideas.

In *Art and Illusion,* E.H. Gombrich argues that it can, and the formalist critics themselves, perhaps unknowingly, imply the same in their ascription to artworks of the power to convey "feelings," "emotions" and "thoughts." All such ascriptions must presume what philosophers have called the Expression Theory of art—that the artwork expresses a feeling or a complex of feelings. But, as Aristotle said, one cannot feel anything unless one feels something. It cannot be a generalized feeling or thought that is expressed, it must be a feeling or thought of a particular type.[69]

If paintings express "feeling," and if "feeling" must be some particular feeling, then the implication is unavoidable that feelings have recognizable visual correlates—that is, that the relationship between the feeling expressed and the form expressing it is motivated. There is then no limitlessness of interpretation. The feeling- or thought-content is recognizably

related to the formal properties of the work, and grounded in them. The work has "placed itself" within a limited range of interpretation. The content is not added on but inherent. This conclusion, of course, is diametrically opposed to the doctrine that the work is purely optical. If art were in fact a purely optical experience then it would be like the experience of a robot, and could not involve "feelings."

> *Statements do not have to be explained: they must be understood. Gazing at a kouros we feel the impact of Parmenides's dictum that man is an "all in the now."*
> *—Nicolas Calas*[70]

If the relationship of representation can be extended from physical objects to thoughts and emotions, is it then implied that philosophical tendencies also have visual correlates? Are there formal configurations that inherently place themselves within a limited range of philosophical contents? Is it a fact, for example, as design handbooks say, that verticals are assertive, horizontals quiescent, and diagonals dynamic and transitional? Does a ziggurat-like form inherently suggest the idea of hierarchy? Does a monochrome surface inherently suggest the idea of unity? This last question can be pursued briefly, since so many practitioners of monochrome have made statements about it.

> *Beyond the head, instead of painting the ordinary wall of the mean room, I paint infinity, a plain background of the richest, intensest blue.—Vincent van Gogh*[71]

The earliest paintings in which a one-color surface is unambiguously presented as the art object are the Tantric paintings of the 17th century in which the state of *nirvikalpa samadhi*—the mental state in which only absolute unity is known—is represented by a monochrome surface.[72] This correlation recurs in Goethe's *Theory of Colors* (1810), in which the activity of beholding an unbroken expanse of a single color is said to awaken awareness of universality and to harmonize the beholder with the basic unity of things. Malevich, in writing on the white-on-white paintings, similarly declares them to "signify" infinity and the united ground of consciousness which underlies perceptions of apparent pluralities.[73] Related assertions are made in the writings of Klein, for whom the one-color surface is equated with the alchemical notion of Prime Matter; in Newman's concern with the cabalistic Zim-zum, which, as Gershom Scholem wrote, is "a primal space ... full of formless hylic forces"[74]; and in Reinhardt's focus on the Buddhist Plenum-Void. For Agnes Martin, who acknowledges Taoist influence, monochrome surfaces are "esthetic analogies of belonging to and sharing with everyone."[75] Robert Rauschenberg, in 1951, described his white paintings as "one white as one God ... dealing with ... the plastic fullness of nothing."[76]

The fact that this correlation between a formal configuration and an idea-type is found in at least two widely separated cultures (India and Europe/America), and over a stretch of centuries, may suggest that the correlation is motivated—that the

works, by their formal properties, recognizably place themselves in this area of interpretation.

> *I think of painting as possessed by . . . a structure born of the flow of color feeling . . . Color must be felt throughout.* —*Jules Olitski*[77]

> *I believe these are highly emotional paintings not to be admired for any technical or intellectual reasons but to be felt.* —*Brice Marden*[78]

But of course this does not mean that a monochrome painting can be understood only in this metaphysical way. In fact, around 1960 a new way of talking about monochrome or near-monochrome paintings arose. Under the influence of the complete dominance of formalist criticism, artists limited themselves to speaking of undefined "feeling" and the direct impact of color. The point is that even if there is a more or less objective correlation between particular forms and concepts, it must still interact with the artist's intentions. The artist can willfully override this correlation, thereby introducing levels of tension into his or her work as part of its means of acting or placing itself in the world. A double bind between a manifest visual correlate and an artist's intentional rejection of it has the effect of placing the work in the zone of critical philosophy rather than metaphysics, but does not in the least remove it from philosophical attitude.

The minimal artist has brought to his art concerns that
many feel more properly belong to the field of semantics,
criticism, and art philosophy.—*Allen Leepa*[79]

The history of philosophy shows a separation into two great streams: metaphysics, which builds up constructions of the mind; and critical philosophy, which tears them down, often in an attempt to return focus to direct experience. Both activities are explicitly philosophical. Though our culture has favored philosophers who fill up the mind to those who clear it out, this is a local blindness: for every Pythagoras there has been a Zeno, for every Plato an Antisthenes, for every Hegel a Russell.

In Anglo-American philosophy, metaphysics has been regarded more or less as kitsch since about 1910; as Bertrand Russell said, it is always a type of "wishful thinking." Fifty years later this attitude came into prominence in the art world. Many artists began to regard the metaphysical intentions of a Newman or a Klein as kitschy and to eschew such statements about their own work. At that time they passed from metaphysics to the critique of metaphysics.

When Kosuth referred to "art after philosophy," he seems to have meant simply "art after metaphysics." He was announcing that art had left the realm of metaphysics and entered the realm of critical philosophy (an event foreshadowed in 1913 by the influence of Pyrrho of Elis on Marcel Duchamp). Art, in other words, is no less involved with philosophical

content than it ever was; like our culture in general, it has merely switched its allegiance, for the time being, from one philosophical tendency to another. Art could only remain truly "aloof from philosophical presumptions" (as Kosuth called it) through perfect application of the through-the-eyes-only approach of Greenberg, which, as we have seen, could not be expected from any artist (or critic) who had not been lobotomized.

> *We may admire a Crucifixion of Giotto for a variety of reasons, religious, aesthetic, historical, psychological. The scholar's faultlessness becomes a fault.*
> *—Nicholas Calas*[80]

> *The philosophically most interesting feature of critical interpretation is its tolerance of alternative and seemingly contrary hypotheses.—Joseph Margolis*[81]

An artwork, subject as it is to the complexity of the general causal situation, radiates meaning on many levels. Once we realize that artworks exist in the world and are of it, we are driven to a multi-model approach to criticism. Such an approach would recognize the work as a complex in which different semantic realms coexist and interpenetrate without interfering with one another. But the formalist claim to priority in method assumes that one of these realms (in this case that of physical form) can be called art-as-art, to the exclusion of all the others. This claim, characteristically, begs the question, because it assumes that the word "art" has already been

defined. In fact, aesthetics, like philosophy, is an un-
certain science. The question of whether aesthetic
value is inherent or projected from outside is open,
quite as much as is the question of whether philo-
sophical meaning is inherent or projected. That one
critic should express a formalist model, another a
Marxist, another a philosophical, is nothing unto-
ward. So it seems that criticism, quite like art, ex-
presses a *Weltanschauung* inescapably. It is not a meta-
game above art, but just another game on the same
level, with similar motives and satisfactions. Like
art, it operates on a constantly shifting foundation,
peaking in flashes of special insight. Its greatest
weakness is the dogmatic imposition of special fo-
cuses as if they were ultimate laws.

> *We would be convinced if beauty . . . were subject to*
> *regulation and schematization. Must it be shown once*
> *more that this is without sense?*—*Jacques Derrida*[82]

★ ★ ★

I have argued the following views as a tentative
correction to the residual influence of formalist doc-
trine: (1) that there are serious omissions in formalist
theory in the areas of content and intentionality, and
that these omissions result from illogical assump-
tions at the very root of the theory; (2) that these
illogical assumptions are specific to our culture in the
postwar period and are not confirmed by the practice
of other cultures and times; (3) that the "purely opti-
cal" theory is inadequate to account for the art expe-
rience; (4) that elements from outside the physical

work cannot be excluded from any human mode of relating to the work, and that this is not a matter of personal decision but an outright impossibility; (5) that there is no apparent justification for denying that an artwork's conceptual resonances are as much a part of it as its esthetic resonances; (6) that the artist's intentions, when they are known or recoverable, cannot be neglected and in fact never are, though the critic might pretend that they are; (7) that the art-work exists in a context of both the viewer's and the artist's sensibilities, with all the conditioning and ac-culturation involved in them—it exists, in other words, not as an isolated absolute or an end in itself, but as a rounded cultural object which relates to phi-losophy, politics, psychology, religion, and so forth; and (8) that the ultimate criticism of an artwork would be a multi-leveled complex of interpenetrated semantic realms which would virtually contain the cultural universe in miniature, and that since the same is true of any cultural object, the artwork has no privileged status outside the affections of its devo-tees.

> *What is there in life except one's ideas,*
> *Good air, good friend, what is there in life?*
> —*Wallace Stevens, "The Man With the Blue Guitar"*

Let's admit that formalism became for a time a "secular religion,"[83] and we can understand better the passionate appeal it has exerted. In the '50s and '60s, when the classic formalist essays were written, we all wanted to believe that form in art was a kind

of absolute, a Platonic hyper-real beyond conceptual analysis.

Why did this idea attain such popularity? Politically, it was perhaps a safe response to McCarthyism and the McCarran Act, which for a time frightened filmmakers, artists, and (yes) critics away from political meanings. But perhaps even more basic than this political motivation was a desire for the self-congratulatory pride of the cult initiate. Ultimately the worship of form as an absolute is a distant resonance of the Pythagorean/Platonic doctrine of the Music of the Spheres—the belief that art vibrations pass constantly through the universe and in fact constitute its inner ordering principles. And if we, then, appreciate the "feeling" of a Noland or Olitski, doesn't this mean that we are, as it were, in the inner circle of the cosmos, moved, however dimly, by the Music of the Spheres?

Formalism made us feel good for a while. It was like a superstitious passion. It ran its course. But our world could mandate a similarly forced solution for the present moment.

NOTES

The quotations and footnotes of this essay have emerged as a lacunary map of certain moods in our history (no attempt has been made to make the map complete). Some of the critics quoted have since changed their positions; others were less inflexible than out-of-context quoting might imply (Michael Fried, for example, cautioned sanely that "the formalist critic [should] bear in mind at all times that the objectivity he aspires toward can be no more than relative."[84]) In a sense this mapping is a response to Ezra Pound's dictum,

Every critic should give indication of the sources and limits of his knowledge. [85]

1. Erwin Panofsky, *Meaning in the Visual Arts,* Garden City, New York: Doubleday/Anchor Books, 1955, p. 22.

2. Jack Burnham, *The Structure of Art,* New York: George Braziller, 1971, p. 13.

3. Rosalind Krauss, "A View of Modernism," *Artforum,* September 1972, p. 49.

4. Michael Fried, *Three American Painters,* Cambridge, MA: Fogg Museum, Harvard University, 1965, p. 39.

5. Alan Tormey, "Art and Expression, A Critique," in *Philosophy Looks at the Arts,* ed. Joseph Margolis, rev. ed. Philadelphia: Temple University Press, 1978, p. 359.

6. Cf. Nicholas Calas, *Art in the Age of Risk,* New York: E.P. Dutton and Co., 1968, p.136. By reducing art to pure structure the minimalists make it impossible for the artist to express emotions. When Michael Fried claims that Noland and Olitski are painters of feeling, he does not explain how a structure of concentric circles, a pyramid of V lines, or a monochrome field are to be viewed as expressing feelings.

7. Douglas Davis, "Post Post-Art I," *Village Voice,* June 25, 1979, p. 37.

8. Fried, *Three American Painters.* pp. 33–37.

9. Clement Greenberg, "Modernist Painting," in *The New Art,* ed. Gregory Battcock, New York: E.P. Dutton and Co., 1973, p. 74.

10. Clement Greenberg, *Art and Culture,* Boston: Beacon Press, 1961, p. 6.

11. Clement Greenberg, "Complaints of an Art Critic," *Artforum,* October 1967, p.39; see also Greenberg, "The Necessity of Formalism," *New Literary History* 11 (1971–72), pp. 174ff.

12. Douglas Davis, *Artculture: Essays on the Post-Modern,* New York: Harper and Row, Icon Editions, 1977, p. 140.

13. Frank Cioffi, in *Philosophy Looks at the Arts,* ed. Margolis, p. 320.

14. Greenberg, *Art and Culture,* p. 6.

15. Jonathan Culler, *Saussure,* Glasgow: Fontana Collins, 1976, p. 19.

16. Claude Levi-Strauss, *Structural Anthropology,* English translation by Jacobson and Schoelf, New York: Basic Books, 1963, p. 141.

17. Ibid., p.131.

18. Fried, *Three American Painters,* p. 5.

19. Robert Rosenblum, "The Abstract Sublime," in *New York Painting and Sculpture 1940–1970,* ed. Henry Geldzahler, New York: E.P. Dutton, 1969, p. 357.

20. Fried, *Three American Painters,* p. 14.

21. Joseph Campbell, *The Mythic Image,* Princeton, NJ: Princeton University Press for the Bollingen Foundation, 1974.

22. Calas, *Art in the Age of Risk,* p. 134.

23. Greenberg, *Art and Culture,* p. 139.

24. William S. Wilson III, "Art Energy and Attention," in *The New Art,* ed. Battcock, p. 247.

25. Calas, *Art in the Age of Risk,* p. 145.

26. For related approaches to Mondrian, see Robert P. Welsh, "The Birth of de Stijl Part 1, Mondrian: The Subject Matter of Abstraction," *Artforum,* April 1973, pp. 50–53, and Erik Saxon, "On Mondrian's Diamonds, *Artforum,* December 1979, pp. 40–45.

27. For detailed discussion of this interpretation of Klein's work, see Thomas McEvilley, "Yves Klein, Messenger of the Age of Space," *Artforum,* January 1982, pp. 38–51, "Yves Klein, Conquistador of the Void," in *Yves Klein: A Retrospective,* Houston and New York:

Institute for The Arts and The Arts Publisher, Inc., 1982, pp. 19–88, and "Yves Klein and Rosicrucianism," ibid., pp. 238–254.

28. Greenberg, *Art and Culture*, pp. 171–74.

29. Davis, *Artculture*, pp. 5–6.

30. Wilson, "Art Energy and Attention," p. 251.

31. Fried, *Three American Painters*, p. 22.

32. Davis, *Artculture*, p. 46, referring to Dan Flavin's sculpture.

33. Harold Rosenberg, "Art and Words," in *Idea Art*, ed. Gregory Battcock, New York: E.P. Dutton and Co., 1973, p. 153.

34. Ibid., p. 151.

35. Greenberg, *Art and Culture*, p. 225.

36. Ibid.

37. Burnham, *The Structure of Art*, p. 4.

38. See *Art as Art: The Selected Writings of Ad Reinhardt*, ed. Barbara Rose, New York: Viking Press, 1975, p. 189 and elsewhere. For a fuller analysis of these and related textual comparisons, see Thomas McEvilley, *The Monochrome Adventure: A Study in the Form and Content of Modern Painting*, limited edition, Los Angeles: Full Court Press, 1981.

39. Rosenberg, "The American Action Painters," in *New York Painting and Sculpture, 1940–1970*, ed. Geldzahler, p. 345.

40. Cited by Douglas Davis, *Artculture*, pp. 16–17.

41. Sheldon Nodelman, "Sixties Art: Some Philosophical Perspectives," *Perspecta* 11 (1967), p. 79.

42. Ibid., p. 78.

43. Davis, "Post Post-Art, II," *Village Voice*, August 13, 1979, p. 40.

44. Greenberg, *Art and Culture*, p. 5.

45. Joseph Kosuth, "Art After Philosophy," in *Conceptual Art*, ed. Ursula Meyer, New York: E.P. Dutton & Co., 1972, pp. 158–170.

46. Aristotle, *Metaphysics*, 1006b1–10.

47. The philosopher Antisthenes used the Law of Identity to reject all discourse on the grounds that since A is only A, any nontautological predication, such as that A is B, is absurd. This is the only way in which the Law of Identity can be used as a conclusion of thought, and even when used in this way it applies equally to all things and does not accord to art any special status. For a discussion of this line of ancient thought, see Thomas McEvilley, "Early Greek Philoso-

phy and Madhyamika," *Philosophy East and West* 31, 2 (April 1981), pp. 141–164.

48. Kosuth, "Art After Philosophy," p. 153.

49. As Douglas Davis also has noted, *Artculture*, pp. 16–52.

50. Susan Sontag, *Against Interpretation and Other Essays,* New York: Noonday Press, 1966, p. 5.

51. Ibid., p. 7.

52. Marv Friedenn, *If Horses or Lions had Hands,* Los Angeles: Full Court Press, 1981, p. 73.

53. Sontag, *Against Interpretation,* p. 11.

54. Ibid., p. 14.

55. Ibid., p. 5.

56. Ibid., p. 11.

57. Aristotle, *Metaphysics,* 1075b20, 1029a.

58. J. Maritain cited in Panofsky, *Meaning in the Visual Arts,* p. 5.

59. Ibid., p. 16.

60. Donald Kuspit, *Clement Greenberg: Art Critic,* Madison, WI: The University of Wisconsin Press, 1979, p. 18.

61. Calas, *Art in the Age of Risk,* p. 147.

62. Of course there is precedent for many elements of Greenbergian formalism in early 20th-century art criticism, e.g. in Roger Fry, who wrote of "the esthetic emotion" and of "the pre-eminence of purely plastic aspects" (Roger Fry, *Transformations: Critical and Speculative Essays on Art,* Garden City, NY: Doubleday Anchor Books, 1956, pp. 6–14, originally published 1926).

63. Terence Hawkes, *Structuralism and Semiotics,* Berkeley, CA: University of California Press, 1977, p. 152.

64. Ibid.

65. Margolis, *Philosophy Looks at the Arts,* p. 366.

66. Frank Cioffi, "Intention and Interpretation in Criticism," in ed. Margolis, ibid., p. 324.

67. Ibid.

68. Edward Said, "The Text, the World, the Critic," in *Textual Strategies: Perspectives in Post-Structuralist Criticism,* ed. Josue V. Harari, Ithaca, NY: Cornell University Press, 1979, p. 171.

69. The only cultural context in which one hears claims of undifferentiated awarenesses or thoughts-without-objects is in Vedantic and

other claims of absolute mystical states—and surely that is not what Fried means by attributing "feeling" to the works of Noland and Olitski.

70. Calas, *Art in the Age of Risk*, p. 208.

71. A letter of 1888, cited by R.W. Alston, *Painters' Idiom*, London, 1954, p. 132.

72. For examples see A. Mookerjee, *Tantra Asana*, New York: G. Wittenborn, 1971, pl. 97, and *Tantra Art*, New Delhi, New York, Paris: Kumar Gallery, 1966, pl. 95.

73. Kasimir Malevich, "Suprematism," in *The Non-Objective World*, ed. L. Hilbersheimer, Chicago, 1959, p. 67.

74. Gershom G. Scholem, *Major Trends in Jewish Mysticism*, New York: Schocken Books, 1941, p. 297.

75. *Agnes Martin*, exhibition catalogue, Munich (Kunstraum), 1973, p. 42.

76. Letter to Betty Parsons, Oct. 18, 1951, cited by Lawrence Alloway in exhibition catalogue, *Robert Rauschenberg*, Washington, DC (Smithsonian Institution), 1976, p. 3.

77. Jules Olitzki, "Painting in Color," *Artforum*, January 1967, p. 20.

78. In *Brice Marden*, exhibition catalogue, New York (Guggenheim Musuem), 1975, p. 11.

79. Allen Leepa, "Minimal Art and Primary Meanings," in *Minimal Art: A Critical Anthology*, ed. Gregory Battcock, New York: E.P. Dutton and Co., 1968, p. 208.

80. Calas, *Art in the Age of Risk*, p. 120.

81. Joseph Margolis, *The Language of Art and Art Criticism*, Detroit: Wayne State University Press, 1976, pp. 91–92.

82. Jacques Derrida, *Writing and Difference*, trans. by Alan Bass, Chicago: University of Chicago Press, 1979, p. 18.

83. Davis, "Post Post-Art, I," p. 40.

84. *Three American Painters*, p. 6.

85. In T.S. Eliot, ed., *Literary Essays of Ezra Pound*, New York: New Directions, 1968, p. 56.

On the Manner of Addressing Clouds

It was when I said,
"There is no such thing as the truth,"
That the grapes seemed fatter.
The fox ran out of his hole.
 —*Wallace Stevens*★

"The Plot against the Giant," or, "The Good Man Has No Shape"

Two thousand five hundred years ago the form/ content relationship was a heated philosophical question. Plato thought that content didn't matter at all: form, he said, really exists *by itself,* triumphant in its isolation, crystalline as a dawn light that will never be stained by the heat of a morning. Aristotle, after twenty years in Plato's school, still had a nagging suspicion that the doctrine of pure Form was a priestly trick of some kind. (Hadn't Plato learned it, after all, from the priests at Heliopolis in Egypt?) It

★All titles and interlinear quotations are from poems of Wallace Stevens.

is said that Aristotle, in his own school later, would forego the quest for pure Form and have his students crawling around in the dirt of the garden, classifying types of cabbages.

Plato's establishment was not, officially, a school. It was tax-exempt as a temple to the Muses, the Goddesses of Art, to whom, inside, pure Form was offered as an object of worship. Aristotle was perplexed by this. The crux came when, after years of waiting, he and the other advanced students were told that at last they would hear Plato's legendary lecture on The Good. Anticipation was keen; the day arrived. But cabbage-brained Aristotle again emerged perplexed. This much he tells us: All Plato talked about that day was triangles and squares: It was a geometry lesson! The Good was pure Form! Some of the students emerged in Pythagorean rapture. But Aristotle wanted to know: How do you *see* pure Form? If it is really without content, then it must be transparent, which is to say, invisible. And the master's answer is there, in the seventh book of the *Republic,* where Plato hesitates so long before pulling down the veil before the sanctum sanctorum: We see pure Form, he declares, with the Eye of the Soul! Aristotle, like Descartes later, wondered: Where is that Eye? (In the pineal gland, maybe?) Anyway, when Plato died, he didn't make Aristotle the head of his school, but his cousin, who also had The Eye. Aristotle, perplexed and annoyed, founded his own school and invented natural science. He reasoned that form could only be known through its content, content only through its form. Tit for tat.

Yin for yang. This just seemed like plain speaking. Such pairs of dependent terms, like left and right or yes and no, only have meaning in relation to one another *and* as different from one another. An attempt to split them apart and suppress one, as in Manichaean-type dualisms, can be a communal psychological tragedy—as in the Yahwehistic worship of Father without Mother, Sky without Earth, and so on. But the opposite attempt—the monistic strategy of declaring the two (for example, form and content) to be the same—simply renders the terms meaningless and abandons them as tools. As soon as one pays attention to *how the words work,* both pure Form and the Oneness of Form and Content disappear into an invisibility not of transcendence but of linguistic non-meaning. They go where mistakes in grammar go. They go where the vehicles of metaphors go. They retreat into the Bronze Age myth-talk from whence they emerged, to drift with Amon-Re like mists above the deep.

By the 18th century Plato was finally on the run; the Soul was a laughing stock. The idea of the integral self began to be balanced by attention to the quasi-mechanical aspects of selfhood. The doctrine of the Soul had always been an argument for unchanging totalitarian statehood—from Old Kingdom Egypt to the aristocrat Plato to the doctrine of the divine right of kings in 18th-century Europe: unchanging Soul and the unchanging State were both expressions of the ideal Order, and both would fall together. David Hume, searching for a unifying principle of self, pried his own thoughts apart and

saw that there was nothing in between them;
thoughts chased one another through his mind as
mechanically as billiard balls, with no unifying prin-
ciple connecting them. After the tyranny of Soulism,
anti-Soulism was experienced as freedom. David
Hartley, like a modern behaviorist, reduced human
motivations to mechanical processes of habit-forma-
tion. Julien La Mettrie wrote *Man as Machine* (1748).
Soul was routed, and the dynasties of Europe fell.
But Soulism did not simply disappear; it crept into a
sheltered retreat like Plato's tax-exempt Temple of
the Muses: it crept into art theory and hid there.
From the Cambridge Platonists to the Earl of Shaft-
esbury to Immanuel Kant to Clement Greenberg, it
would now be called: the Faculty of Taste. Behind
this new, antiseptic name lurks Plato's Eye of the
Soul, and behind that the Udja-Eye of Old Kingdom
Egypt, the Eye of Horus, that Sees the Things of
Heaven. The Eye of the Soul simply *sees* contentless
Quality as the Eye of Horus sees the Things of
Heaven. But only, Plato pointed out, for one who
has specially cleansed that orb, which in most of us
remains filthy and dim. And how do you know that
someone's Eye is clean? There's no way to check it.

This Soulism in art theory was soon joined by an
equally myth-based view of history which became
the foundation of the formalist evolutionary view of
art: that history is driving toward this or that end,
and that past events could only have happened as
they did. As a disguised assertion of religious Provi-
dence, it justifies the establishment of tyrannical
authority-structures that claim to express the inner

imperative of history. Friedrich Schelling and Georg Hegel, impressed as youths with the ineluctable appearance of the advance of Napoleon, revived the religious myth that history is advancing toward a final perfection in which Spirit, cleansed of the illusion of Matter, will be totally absorbed in itself. Further, Schelling elevated the aesthetic faculty above the other two postulated by Kant, the cognitive and the practical: Spirit expressed itself through Art, which was, as Hegel said, "the sensuous appearance of the absolute." Art-making, then, became the most crucial and urgent of all human activities: by driving art history along the path of formalist evolution toward the goal of pure Spirit/Form, the artist actually hastens (as by a kind of sympathetic magic) the advance of Universal Spirit toward Perfection. (According to this view the self-absorbed rapture of Spirit at the orgasmic End of History would be a kind of universal art event.) This myth, which lays upon art the terrifying responsibility of perfecting Spirit, exerted an unhealthy influence on artists and poets, who, in earlier cultures, had not been noticeably more tortured, alcoholic, or suicidal than other small producers or artisans.

In this century, we have seen pendulum swings away from the worship of pure Form in various movements that have explicitly rejected the primacy of formalist esthetic values. The basis of the rejection was stated by Marcel Duchamp when, in reply to Pierre Cabanne's question "What is taste?", he replied, "Habit." In an age that has seen that language-systems are conditioned, such an insight was inevita-

ble. Canons of taste, as seen by ethnology and philosophy, must be regarded not as eternal cosmic principles, but as transient cultural habit-formations. The elements praised by formalist critics have specific coded values in their habit-systems. For someone to have "better" taste than others, then, is for that person to sense and exercise the communal habit-system with unusual attention and sensitivity. The exercise of one's esthetic habit-system on artworks exquisitely expressive of that same system produces a pleasant sense of recognition, identification, and confirmation. The shape of the esthetic habit will change as the web of conditions that contains it changes. Yet only the present habit ever seems real—as the smoking habit is real to one who has it and strangely unimaginable to one who does not. One rarely remembers changing one's taste— yet the history of the changes is there. This is why there is always more formalist work for artists to do: reshaping the aesthetic habit-system for the needs of a new now. Understood in this way, seeing with the Udja-Eye of keen aesthetic habit is tragically far from the experience of transcendentally free vision that its proponents have hoped it might be. In fact, it is the opposite: a bondage, a limitation, a groundless prejudice imposed by ambient conditions. Specific habit-systems are defended with actually religious zeal, and to be mistaken has, to the believer, the monstrous import of a religious mistake: it is no less than an indictment of one's Soul.

The literature of formalist criticism contains, throughout, the odd blindnesses and repressions

typical of religious texts, including a system of taboos. One such is an example of *euphemia*—the obligation to speak only propitious things while acting in a priestly capacity. To study content, the formalists seem to feel, would be like studying the Devil rather than God. Content, as Susan Sontag wrote, was a kind of "philistinism." To ignore it highmindedly was, then, a sign of virtue, a sign, really, that one was among the elect. Even to look at the question of content would be to submit oneself to a degrading invitation. This puritanical avoidance of the question has become institutionalized. But the age of the formalists' creative blindness—the age of their great insights into the Modernist aesthetic habit—is long gone, and the question of content remains. There are those who have made inroads into it from various directions—Walter Benjamin and Louis Althusser, Harold Rosenberg and Nicolas Calas (to name some important examples)—and those who have significantly clarified the question—Erwin Panofsky and E.H. Gombrich, the philosophers Nelson Goodman and Timothy Binkley—but the simple question has never yet been directly asked and directly answered: What *is* content, anyway? And, are *we* involved?

"Thirteen Ways of Looking at a Blackbird"

Everything we might say about an artwork that is not neutral description of aesthetic properties is an attribution of content. (Even value judgments, insofar as they reflect what Althusserian critics call "visual ideology," are implicit attributions of content.) If there is no such thing as neutral description, then all statements about artworks involve attributions of content, whether acknowledged or not. There are many possible ways to sort these things out; one is on the model of geography—what types of content arise from this or that location in the artwork?

1. Content that arises from the aspect of the artwork that is understood as representational. This type of content is widely regarded as the least problematical; ironically, this very assumption lies at the heart of a tangled problem. We tend to feel that representation works by a recognizable element of objective resemblance, yet it seems more accurate to say that what we experience as representation is, like aesthetic taste, a culturally conditioned habit-response not involving objective resemblance. In fact, it is difficult if not impossible to say what would constitute objective resemblance. And in reverse, the conviction of objective resemblance habituated in our pictorial tradition seems to exercise control over our perception of nature. The pictorial tradition, presented to us as representation of nature, has remade our perception of nature to conform with the con-

ventions of pictures (as Goodman and others have demonstrated in their critiques of representation and, especially, of the tradition of perspectival drawing). The resemblance we seem to see between pictures and nature does not result from the fact that art imitates nature, but from the fact that our perception of nature imitates our perception of art. Seen thusly, just as it seems we can't think anything that our language can't formulate, so it seems we can't see anything that our pictorial tradition does not include or imply.

Representation, then, especially two-dimensional representation, is not an objective imitation, but a conventional symbolic system which varies from culture to culture. What "looks like" nature to an Australian aborigine looks like symbols to us, and vice versa. Virtually every culture has a tradition of representation which it sincerely regards as based on resemblance. Faced with a painting of the Battle of Waterloo, we seem to recognize horses, weapons, warriors, and so on; what we are in fact recognizing are our conventional ways of representing horses, weapons, warriors, and so on. The fact that it is specifically the Battle of Waterloo must come from the next level of content.

2. Content arising from verbal supplements supplied by the artist. Duchamp's famous remark that the most important thing about a painting is its title points to a weakness in the "purely optical" theory of art. Artists frequently issue verbal supplements in an attempt to control the interpretation of their works, and even the most optical of critics cannot

help but be influenced by them. In reference to a painting of horses, and weapons, and warriors, for example, the title "The Battle of Waterloo" injects a specific content arising not from optical features but from words. Abstract and reductionist art, as much as representational, has been dependent on content supplied in this way. For example, it would be virtually impossible (as Harold Rosenberg once remarked) to distinguish the Minimal from the Sublime without such verbal supplements as Barnett Newman's cabalistic titles, the published interviews with Frank Stella and Donald Judd, and so on. Robert Smithson's essays have controlled the interpretation of his works, as Yves Klein's essays have of his. This quality goes back, really, to the beginnings of art: to Pheidias' identification of a certain nude male sculpture as Zeus rather than, say, Poseidon or Apollo, to the texts accompanying Egyptian tomb paintings, to the shaman's explanatory song in front of his paintings. It is as important today as it ever was.

3. Content arising from the genre or medium of the artwork. This type of content shifts as ambient cultural forces shift. In the 1960s in America, for example, a contentual dichotomy between painting and sculpture arose. Painting came to imply a lack of direct involvement in experience, an absorption in indirect, distanced preoccupations. Sculpture, on the other hand, was understood, even when representational, as a *real presence of objecthood,* since it occupied the same space the viewer occupied, the space of embodied life. From this ethical dichotomy arose

much of the dynamic of the art of the 1960s and '70s. The radical new genres were associated with sculpture, performance being called "living sculpture," installations "environmental sculpture," and so on. Painting was associated with the old values of convention, rather than actuality. For an artist to choose to work in oils on canvas was seen as a reactionary political statement—whereas in the 1950s oil and canvas has signified freedom, individuality, and existentialism. This dynamic was at the root of the great acceleration, in the 1960s and '70s, of the project of sculpturizing the painting, of asserting it as an object in real space rather than as a window into illusionistic space. Three-dimensional objects were added to canvases to link the representational surface to sculptural presence. Shaped canvases were similarly motivated. Explorations of ways to combine colors without producing a figure-ground relationship were another aspect of the effort to produce objects that, while recognizably paintings, were not compromised by suggestions of representation. The content inherent in the media and genres had attained political and cultural significance that asserted itself alongside the significance of the art objects themselves.

History can provide countless examples of this type of content, not least the distinction between popular and elitist media (in ancient Greece, for example, the vase painting versus the sculpture) and that between male and female media (for example, in neolithic societies which restricted pottery-making and basket-making, that is, vessel-making in general, to women's groups).

4. Content arising from the material of which the artwork is made. Within the category of sculpture in the 1960s and '70s, an artist working marble representationally was at one level making a statement opposed to that of the artist working with industrial I-beams or fire. Traditional art materials, industrial materials, esoteric high-tech materials, absurdist materials (like Ed Ruscha's chocolate), neoprimitive materials (like Eric Orr's bone and blood), pantheistic materials (Klein's fire, and so on), deceptive self-disguising materials (plastic that looks like plaster, wood prepared to look like stone)—all these decisions by the artist carry content quite as much as form. They are judgment pronouncements that the art viewer picks up automatically without necessarily even thinking of them as content. They are statements of affiliation to, or alienation from, certain areas of cultural tradition; as, say, the use of industrial I-beams represents a celebration, or at least an acceptance, of urban industrial culture, while the use of marble or ceramic suggests nostalgia for the pre-Industrial Revolution world.

5. Content arising from the scale of the artwork. The New Kingdom Egyptian custom of sculpting pharaohs and their consorts much larger than life (as at Abu-Simbel) is an obvious assertion of political content, a portrayal of the hereditary monarchy and its representatives as awesomely given, like those parts of nature—sea, sky, desert, mountain—beside which ordinary human power and stature seem trivial. Such channels of content are not objective and absolute but culturally shifting: it is possible to con-

ceive a society that would associate unusual small-ness with special power or efficacy. In the Roman empire an emperor was sculpted during his lifetime about life-size; after death and deification, about twice life-size. Obviously, decisions of scale have formal significance; their contentual significances should be equally obvious. John Berger, among others, has pointed out that the portability of the easel painting was a signifier of private property. The increased scale of paintings from Barnett Newman onward suggests a more public arena—a society dominated by large institutions rather than by private individuals. The huge scale of many paintings today functions in part as a denial of transience through an implied reconstitution of the architectural support. Scale always has content, yet we read it so quickly that we hardly notice.

6. Content arising from the temporal duration of the artwork. The Platonist view that underlies the masterpiece tradition was stated by the Roman poet Seneca: "Vita brevis est, ars longa": life is short, art long. The artist's work, that is, was expected to outlive him or her. This hope went back at least to Sappho (6th century BC), who said that her poems would bring her immortality. The time-reality in which the artwork lived was not precisely historical time: its proper time dimension was a posterity conceived as a mingling of historical time and eternity—the artwork would survive through historical time *forever,* like Sappho's undying roses. With it something of the artist's Soul (its trace at least) also became immortal. In terms of Greek philosophy, the

artwork has crossed a metaphysical boundary like
that at the level of the moon, below which things
die, above which, not. Great art, in other words,
was regarded as having captured something of
deity—as Quintilian said of Pheidias' Zeus. That di-
vine spark inside the artwork is its immortal Soul,
which enables it, like the magical ritual, to penetrate
through to higher metaphysical realms and to act as
a channel to conduct higher powers downward while
yet keeping them pure. We are all familiar with this
view. Even in comedies, artists seek immortality.
One silly poet of the Roman Empire is survived only
by a scrap of verse saying that his oeuvre would
outlast the ages.

This view of artworks goes back to times when
they were sanctified objects made for use in rituals.
It is primitive magic plain and simple, which ritually
abolishes historical time. It typified Egyptian tomb
art, which portrayed the places and things of eternity
and was itself magically equivalent to them; it goes
back probably to those Magdalenian paintings in the
distant depths of caves, beyond the reach of the
changes of night and day. Yet despite the extreme
primitiveness of its beginnings, this theory of art
came into Romantic Europe whole, and has survived
to the present day. Goethe quite as much as Proper-
tius—and Dylan Thomas as much as Goethe—ex-
pected to be singing his poems in a chariot driven
by the Muses toward Heaven.

Works with exaggeratedly durable materials—
such as the granite in which the Egyptians carved
pharaohs—participate in this Platonic daydream of

transcending the web of cause and effect here below. The idea, of course, is integral to the formalist Modern tradition, which is throughout solidly founded on primitive thoughts and intentions. It is why the artwork is held to have no relation to socio-economic affairs: it has transcended conditionality and, by capturing a spark of the divine, has become an ultimate. Signs of this metaphysic virtually ooze from the works made on its assumption, which can be detected not only by the durability of their materials but also by the pomposity that surrounds their aesthetic displays.

Just as clearly, an opposite metaphysic is asserted by works made in deliberately ephemeral modes or materials—a metaphysic affirming flux and process and the changing sense of selfhood. The obsessive expectation of posterity is linked with the belief in Soul and constitutes, in effect, a claim that one *has* a Soul. Works affirming flux involve the opposite assumption, that the self is a transient situation arising from the web of conditions and subject to its changes.

7. Content arising from the context of the work. When the work leaves the artist's studio, what route does it take into what part of the world? This decision always has political content. Mail Art and other strategies to bypass the channels of commodification are expressions of resistance to the processes of commodity fetishism and are gestures toward the abandonment of exchange value and the regaining of use value. Other kinds of content cling to specific contextual situations. The release of a commodifiable

aesthetic object into the marketing network often carries with it an opposite burden of content. It wants to be bought, and like anything that wants to be bought its attempts to ingratiate itself with prospective buyers are obvious, no matter that it may have been made by a monument of integrity such as Jackson Pollock. These are things that one must cock one's head slightly differently to see—and then at once they become obvious. All art is site-specific to that degree. Declaredly site-specific art involves selection of context as a major contentual statement: Is the work protected apart in a distant fenced compound of the New Mexico desert? Or is it thrown down in one section or another of an urban downtown? The contentual aspects of such decisions are as important as their formal aspects are.

8. Content arising from the work's relationship with art history. When the historicist drive is greatly exacerbated, as at the height of the Greenberg era, there is also a mythic-millennialist content which carries with it a weight of German metaphysics and residual Neo-Platonic spirituality. The myth of the evolution toward the innocent Eye suggests a drive toward the paradise at the End of History. The opposite of this complete affirmation of art history as a cosmic-spiritual directionality is an iconoclastic approach, sometimes expressed in deliberate primitivism. Yet in a sense this type of movement is an attempt to roll back the tradition of vision to the earlier phase of innocence, the paradise *before* history. These two movements, though opposite, complement one another.

The most common mode of content arising from the work's relationship to art history is in the use of allusions and quotations to assert a special relationship with some other work or tradition of works. James McNeill Whistler's introductions of references to Japanese painting and the Cubist references to African art are examples of such content, commenting, in both cases, on the closedness of the Western tradition and suggesting alternative aesthetic codes beyond it. Lately, the most common type of allusion has been to earlier works in one's own tradition. This level of content is so important to our present moment that I will discuss it in detail later.

9. Content that accrues to the work as it progressively reveals its destiny through persisting in time. I mean here much what Walter Benjamin meant when he said that a man who died at age 30 would forever after be regarded as a man who, at whatever stage of his life, *would* die at age 30. Whatever occurs to a work as its history unfolds becomes part of the experience of the work, and part of its meaning, for later generations. Duchamp added content to the *Mona Lisa;* Tony Shafrazi to *Guernica,* and what's-his-name to Michelangelo's Saint Peter's *Pieta.* The fact that Greenberg used Pollock's works as proofs of the idea of contentless painting is now part of the content of those paintings.

10. Content arising from participation in a specific iconographic tradition. Iconography is a conventional mode of representing without the supposition that natural resemblance is involved. Thus to Christians blue may be felt as Mary's color without a sug-

gestion that it *looks like* Mary. Through iconographic conventions, identifications and comments are made through conventional signals. A Christian, for example, sees not a human woman talking to a bird-winged man, but the Annunciation. To a Hindu a crowned man on a bird is Vishnu and Garuda, with all the myths and feelings associated with them called instantly into play. At less conscious levels are iconographic messages in movies, from the white and black hats in early Westerns to, say, clothing semiotics in *Scarface*. Context signals us toward one response or another: for example, the ringing telephone in a love film may signal an assignation, while in a gangster film a contract for assassination.

Whether some widely-distributed iconographic conventions are based on innate psychological foundations, such as Jungian archetypes, is an unanswerable question, but it is clear that inherited conventions of this type saturate our responses and are effective in a hidden way in many artworks. One critical approach to 20th-century art that has been very little used, yet is remarkably fruitful, is to subject it to interpretation in terms of the iconographic stream that goes back in both East and West, to the ancient Near East and beyond. Willem de Kooning's "Women," for example, may profitably be compared with goddess-representations from Hindu Kali to Egyptian Isis to the leopard goddess of Catal Huyuk.

11. Content arising directly from the formal properties of the work. The formalist idea that abstract

art lacks content is rightly seen today as archaic. It seems the associative and conceptualizing activities of the human mind go on constantly and transpire in an instant. Thus we see everything within some frame of meaning. If perceptions truly had no content whatsoever they would be blank moments in consciousness and would leave no trace in memory. At one level, formal configurations function as ontological propositions. Merely by shaping energy one models the real; every grasping or shaping is a rhetorical persuasion for a view of reality. Critics commonly have asserted that music has no content. But, for example, Beethoven is widely experienced as presenting a view of reality as stormy, turbulent, and full of passionate striving, while Bach presents it as serene, cool hyper-realms of sensuous mathematical order. A Pollock drip painting asserts flux and indefiniteness of identity as qualities that can be found in the world. This tautological interface between form and content is not a mystical attempt to unify opposites. It simply means that a work *demonstrates* a type of reality by embodying it. Thus abstract art, far from being non-representational, is, in effect, a representation of concepts; it is based on a process like that of metaphor, and overlaps somewhat with both iconography and representation.

This level of content is involved in value judgments, since it relates especially closely to the content of visual ideology (though visual ideology arises from all levels of content at once); hence, it confuses aesthetic issues somewhat. The assertion by Althus-

sierian critics that aesthetic feeling is merely and exclusively a response to visual ideology is based on the Lacanian model of how the self constitutes itself from the surrounding cultural codes and then, looking at these codes again, seems to recognize itself in them. Whether a purely aesthetic level of response can ever be isolated from the encroachment of this process is a major question in art today.

12. Content arising from attitudinal gestures (wit, irony, parody, and so on) that may appear as qualifiers of any of the categories already mentioned. This level of content usually involves a judgment about the artist's intentions. The desire to persuade, for example, is a form of intentionality that saturates some works and involves itself in all their effects. John Keats referred to such a situation when he wrote, "We hate poetry that has a palpable design upon us." Our word "propaganda" means much the same. In irony, wit, and so on, some level of content is presented by the artist with indications that his or her attitude toward it is not direct and asseverative but indirect and perverse. The process is complex. The viewer's mind compares the statement received with another hypothetical statement which the mind constructs as representing the normal or direct version, and by contrast with which the abnormal and indirect approach can be perceived and measured. Thus ironic indirection, entering into any other category of content, criticizes that content at the same time it states it, and alters the charge of meaning.

13. Content rooted in biological or physiological responses, or in cognitive awareness of them. Vari-

ous claims have been made about types of communication that operate on a purely physiological level. (In fact, formalism, with its "purely optical" trend, was a claim of this type, while with its "faculty of taste" it introduced a supernatural ally to the optic nerve.) Sebastiano Timpanaro and others have suggested that some types of subject matter, such as sex and death, appeal to us because we know that we are organisms subject to death and involved in sexual reproduction; these responses, then, are prior to socio-economic acculturation. Contentual readings that may be closer to pure physiological responses would include the stirring of the genitals in response to pictures of sexual subjects, the phenomenon of fainting at the sight of blood, or of becoming nauseous from viewing gory pictures; and so on. This is the level of content that is often denounced as "sensationalism"—sex and violence—with the denunciation presumably based on a sense of how easy it is to construct images that will elicit such responses. Some psychological research has suggested innate responses to colors, blue for example (perhaps contrary to popular notions) arousing feelings of aggression and pink of peacefulness. (There is an odd parody here of what the formalists sometimes called the "feeling" of color.)

Perhaps the psychoanalytic content associated with the theories of D.W. Winnicott belongs in this category, on the grounds that it arises from memories of primordial phases in the development of the organism. In relation to painting, Winnicott's work suggests (not for the first time) an equation between

the figure-ground relationship on the one hand and the ego-world relationship on the other. Work that emphasizes the ground, or an ambiguous condition in which figure is almost completely merged into ground, expresses the ego's desire to dissolve itself into a more generalized type of being, on the remembered model of the infant's sleep on its mother's breast. Work that emphasizes figure, or clear separation of figure and ground, expresses a sense of ego-clarity, and a fear of ego-loss or of the loss of the clear boundaries between ego and world. (In more traditional terms, these are, respectively, the Dionysian and the Apollonian.) All artworks, I think (perhaps all human actions of any type), express an attitude on this question, no matter what else they express. In some cases this question is brought into the foreground as a primary artistic content; Barnett Newman, Mark Rothko, Ad Reinhardt, Agnes Martin, and others have all portrayed the moment when ego begins to differentiate itself for the dual-unity (as Geza Roheim called it) with the mother's body. These artists saw in their own work a metaphysical moment that is a correlate of this psychoanalytic moment: the subject of "Creation," "Beginning," "Day One," "The Deep," and so on—the first emergence of differentiated things from the primal abyss of potentiality (compare Winnicott's term "potential space," which also correlates metaphysically with prime matter). Seen in these metaphysical terms this content can also be placed in the category of content arising from the formal properties of the work by a process like that of metaphor.

★ ★ ★

This list of thirteen categories is like a series of sample sightings of some great beast (Meaning) whose behavior is too complex to be fully formulated. As long as we chose to look for different ways to sort these things out we would find them. The categories I have presented overlap and interpenetrate at various places. (It would be foolish to expect a crisp set of categories from an activity of mammals.) Furthermore, as long as we choose to look for more ways in which the mind reads meaning out of an artwork, we would find them, too. Each possible network of relations between categories is itself another means of conveying a precise, if complex, content, and the possible networks and meta-networks of relations among the thirteen listed above proceed toward infinity.

The relation between content arising from representation and content arising from formal properties is a prominent example of this type of interaction. To show Wellington at Waterloo with Goyaesque grotesquerie, or with expressionistically fraying edges denying the integrity of ego, would add to the subject matter a thematic content involving denial of heroic integrity, or some such. Similarly, grandiosity of scale can conflict with triviality of subject matter, as in much Pop art. Indeed, conflicts between all levels can occur, and in infinite regresses of complexity which cannot be individually defined here. A work that *features* contradictions among its levels of content thereby gains yet another level involving concepts like paradox, inner struggle, tension, and

negation of meaning-processes. On the other hand, works that exhibit a high degree of harmony or mutual confirmation among the various levels of content tacitly model the real as integrated, whole, and rich in meaning, somewhat in the manner of the traditional masterpiece.

Not all works, of course, have all levels of content. Abstract art, for example, has eliminated naive realist representationalism. The number of levels that are in fact discernibly present (or absent) provides us with yet another level of content. Works in both the Minimalist and the Sublime directions, for example, exhibit an attempt to eliminate content or at least to reduce the number of contentual levels present in the work. This attempt in itself declares or acts out a new level of content; no work ever attains the zero-degree of content, since the concept of a zero-degree of content is itself a content. In combination with other levels (primarily verbal supplements by the artist) this content may express the Minimalist ethic, or the Sublimist, or an impersonalist ethic, as in much International-style architecture. In 20th-century painting this anti-contentual content has been of enormous importance. From Malevich to Klein to Newman, attempts were made to represent concepts like void, emptiness, prime matter, and the absolute by plastic analogues of the characteristics of solitary grandeur, nondifferentiation, and potentiality. In contrast, works of the traditional masterpiece type—from the Sistine ceiling to *Guernica*—tend to articulate as many levels of content as possible in

their portrayal of a full-bodied sense of rich, meaningful involvement in life.

This list of contents that arise among categories could be extended indefinitely. What is essential is that we begin to appreciate the complexity of what we do when we relate to an artwork. Far from being a "purely optical" and unmediated reflex, the art event is an infinitely complex semiotic Bead Game involving many different levels and directions of meaning, and infinite regresses of relations among them. Let's forget for a moment the Eye of the Soul and think of the marvelous mammalian brain which instantly reads out these many different codes, keeps them separate while balancing and relating them, and produces a sense of the work in which all these factors are represented, however transformed through interplay with the particular receiving sensibility. Far from a simplistic philistinism, content is a complex and demanding event without which no artwork could transpire. It demands our attention since without awareness of these distinctions and levels we do not really know what has happened already in art, and what is happening now for the first time.

"Prologues to What is Possible," or, "What We See Is What We Think"

An overwhelmingly important aspect of content is its pivotal role in defining genres and oeuvres. By

foregrounding an element of content usually taken for granted and invisible, a whole new artistic mode or direction can be discovered. Content arising from scale, for example, has been foregrounded in various ways by such 20th-century avant-gardists as Claes Oldenburg, whose oversize baseball bat and the like involve scale not only as a formal but also as a contentual element, and Walter de Maria, whose *Two Parallel Lines* (1968), in the Nevada desert, isolates scale and foregrounds it as a leading principle. In both cases the content of scale has to do with human scale, with relativity, with image multiplication, with the dichotomy culture/nature, and so on.

The content of context also long seemed fixed and invisible, as the church, museum, gallery, or, most recently, the bank building, seemed the natural or given arena in which to see art. Dada foregrounded context as content, aggressively investigating contexts (the Cafe Voltaire, the public urinal) whose contents were implicit critiques of the museum-like space and the Platonic metaphysic implied by its efforts toward timelessness. Duchamp and more recent artists such as Marcel Broodthaers, Daniel Buren, and Michael Asher have foregrounded context as a primary signifier in their work.

Duration is another category that in our culture has been regarded as fixed in one form *(ars longa),* any deviation from which once seemed actually unrecognizable as art. More recently, ephemeral works of various kinds have foregrounded the aspect of duration. Richard Long's documented walks through countrysides, for example, pointed to the contents of

context and duration—as Earthworks foregrounded context and scale. The Dada performance in which Francis Picabia drew on the blackboard while Andre Breton erased behind him involved a combination of duration content with iconoclasm (a relation to art history).

What must be stressed is that these aspects of content were always there, but they were not elements that artists consciously worked with. An art establishment rigidly fixed in the mood of Platonic transcendentalist bourgeois capitalism promoted the myth that these elements were fixed or given, the contents they expressed were thus made to seem natural and hence invisible—unacknowledged parts of the "visual ideology" of the cultural mode. The point is that these categories of content were exercising their effect without anyone realizing it; we received their messages without realizing that they were sending them. One of the great achievements of anti-formalist periods of 20th-century Western art is precisely their deliberate foregrounding of categories of content that had been working on us unnoticed for so long.

The content that arises from contradiction among levels of content has occasionally moved into the foreground. Goya stayed afloat through a straight-faced use of it. Pop art foregrounded it: the iconic mode was mocked by mundaneness of subject matter, grandiosity of scale by triviality of subject matter, and so on. In general, Pop art employed the clean, hard-edged representation that implies a world of ontological integrity composed of entities with

fixed and knowable identities; yet the allusive or quotational content, with its references to a despised popular culture and to information as random, neutral, or meaningless, decried this declaration of ontological integrity as a sham or con job. (To the extent that the efficacy of Pop art was primarily critical rather than aesthetic it was rightly called Neo-Dada.)

The history of art needs to be rewritten with attention to the different modes of content that have been foregrounded in different traditions and periods. The subject must be vastly oversimplified here to give the merest glimpse of how such a project might proceed. The recent history of content, for example—of, say the last century or so—may be described (on *one* level) as expressing a constantly intensified attention to the question of representation. A belief in representation—though variously formulated—was pretty well in effect through much of the 19th century. It lost credibility not only through the advent of photography, which reduced to absurdity the conventional admiration for the skill of it all, but also through ethnological contact with societies whose conventions of representation were very different from ours, and equally supposed to be objective. Australian aborigines, according to anthropologists who have worked with Australian primal peoples, had difficulty seeing a resemblance between an object and a photograph.

So-called abstract art challenged the (discredited) inherited canons of representation and explored new ones which, since they differed from the established type of representation, were not recognized as repre-

sentation at all. I mean, of course, the modeling of reality along broad conceptual and emotional lines that replaced the representation of material objects and which was called, somewhat inaccurately, non-representational art. This metaphysical representationalism culminated in the tradition of the Sublime, which was precariously based on two types of content: the content of attempting to eliminate content, and the content provided by verbal supplements. The problem lay precisely in its dependence on those verbal supplements. Kant asserted that the three human faculties (aesthetic, cognitive, and practical) were independent of one another; this meant that no verbal (i.e., cognitive) formulation could ever approach the aesthetic experience. Largely under the influence of this doctrine, formalist critics from Benedetto Croce to Clement Greenberg denied the appropriateness of any acknowledgment of content whatever. Many of the artists whom these critics represented—and on whose work they based their arguments, supposedly—did not agree with this at all. In written supplements in the form of titles, interviews, essays, and catalogue statements, artists from Kandinsky and Mondrian to Rothko and Newman rejected the pure form analysis of their work and specified the contents they intended it to carry— contents generally in or near the category of the Sublime. This is why formalist critics in their heyday insisted that one should never listen to artists. This urgent disagreement between artists and critics was confusing. Greenberg, Michael Fried, and others were such powerful advocates of their way of seeing

that they defined a communal habit for all of us. Discovering their correctness in our own habit-system—once they had showed us how—we felt it as simply given, like nature or the cosmos. When the art public began to realize with unease that our great artists of the '50s were in fact metaphysical conten-tists, and not aesthetic purists like their critics, the work lost a certain credibility. It stood awkwardly revealed as just another mode of representation.

This discovery was followed by a phase of openly ironic representation—Pop art—which collapsed the idea of the Sublime into the Brillo logo. Alongside it arose, as another reaction, an attempt not to repre-sent anything at all, but just to be: Minimalism, which led unaltered rock piles into the art catalogues. Conceptualism in turn eschewed all visual modes ex-cept as tools of critical insight (rather than aesthetic delight): representation and the various ironic rela-tions to it became tools in a critical vocabulary.

More recently the recognizable 20th-century modes of representation have returned to the center of the artistic vocabulary—but with attitudinal in-versions that render them less straightforward than the first time we saw them. Additional contents of quoting, irony, and contradiction between semiotic levels have been added to the content of representa-tion. Representation in these works is not based on the naive assumption that it resembles nature. What are being represented are *modes of representation* them-selves. Through quoting, the process of representa-tion is simultaneously acted out and criticized: its cultural-conventional roots are laid bare at the same

moment that they exercise their effects upon us. There is a great cultural dexterity to this—to seeing one's delusion while one is still deluded by it.

> ... *To say of one mask it is like,*
> *To say of another it is like*
>
> *To know that the balance does not quite rest,*
> *That the mask is strange, however like.*

The recent wave of quoting has to be distinguished from various earlier visual activities that superficially look like it, including cultural diffusion, artistic influence, and homage. It is very different from the quoting of alien cultures as part of a process of learning. The Egyptians quoted the Sumerians; the Greeks the Egyptians; the Romans the Greeks; the Renaissance Italians, the Romans. This was the trail of civilization as it diffused its elements from culture to culture. Quoting in this sense is receiving, acquiring, learning. What we are presently dealing with is a very different semiotic transaction, a quoting of things already acquired or learned by every member of the intended audience, a passing around, in new combinations, of things we already have. This activity is rooted, in our century, in Duchamp's use of the quotation of iconic images as a critical instrument, in Picabia's quoting of styles-as-things, and in other Dada-connected strategies (including Kurt Schwitters' collages). Pop art, at the end of the Abstract-Expressionist last gasp of Soul, locked it in place.

To a degree, the purpose of Dada—and of Pop as

Neo-Dada—was to reveal the semiotic impersonality of the art process and to ridicule the idea of Soul and its timeless products. To this end Dada vulgarized the iconic and Pop iconized the vulgar. More recently the quoting activity has been enormously accelerated. Artists have quoted, with or without overt displays of irony, a huge range of art-historical materials, both images and styles being used as found objects: references to the Ionic frieze, the Roman sarcophagus, Baroque mythological allegories, and Paleolithic wall engravings coexist with exact rerenderings of Pollock, de Kooning, Tanguy, Leger, less exact rerenderings of broad stylistic types, from Neo-Expressionism to Neo-Hard-Edge-Abstraction, and a great deal more that is by now familiar. The process works in various ways. An entire work can be a rigorously exact quote of an earlier work (that is to say, a copy of it); a new work may incorporate one or more quoted elements into an original format; styles and genres of the past may be loosely quoted or referred to; a familiar icon may be quoted with some significant change such as a difference in scale or context; an object from the nonart world may be quoted in an art context; and so on.

What is involved here is more than the Duchampian critique of art history and of the aesthetic theory of art, more than the Picabian investigations. It is in addition a very special kind of *fin de siecle* inventorying: an inventory not merely of classical styles and images but more particularly of the critical insights of this century—of the critique of aesthetics, of representation, of art-historical histori-

cism, indeed of all the value projections that the culture as a whole has cast upon neutral information.

This activity has variously been called Alexandrianism and post-Modernism; as the latter term suggests, its meaning is inseparable from that of Modernism. John Dewey stressed the aspect of Modernism that is important here: the conviction that with reason, pragmatism, and good will, human communities can identify and solve their problems, ever more perfectly implementing the ideal of the greatest good for the greatest number. History, in this view, is regarded as a process of problem-solving, driven by an inner imperative toward progress. This ideology arose under heavy Greek influence in the 18th century, and gained momentum in the 19th from the irrational extension of Darwinism to cultural as well as biological affairs. The reflection of Social Darwinism in art criticism was the historicist view that at every moment there is an art-historical imperative, an urgent need to "solve" a certain set of aesthetic problems which have been left behind by the last solution to the last problem. This "tradition of the new" has only occurred in democracies; the opposite stance—resistance to change, an attempt to make change appear taboo or unnatural—has characterized cultures with hereditary rulers or self-perpetuating ruling cliques. The most successful instance is ancient Egypt, where, for example, the canons of representation through drawing went unchanged for about two thousand years without solving elementary problems of foreshortening. It is no accident that the form of government did not change in that

time either, or that the idea of the Soul—the idea
that human nature is, in essence, unchanging—was
first (it seems) clearly formulated there. The ideal
order of things was affirmed by all this (and an aspect
of that order, of course, was class structure).

It is important that we realize that our Modernism
is not unique. In an earlier instance, in the ancient
Greek democracies from about 550 BC till about 350
BC, the tradition of the new was fully in effect in
literature, music, and the fine arts, as well as in social
and political experimentation. The achievements of
the sculptors Pheidias and Polykleitos posed the
problems for Lysippos and Praxiteles, and so on.
Euripides and other poets transformed the inherited
metrical system into complex free verse, as happened
in late-19th-century poetry in Europe and America.
Timotheus, Euripides' friend, and other composers
called the New Musicians, leveled distinctions be-
tween modal harmonies with an increasing chro-
maticism which parallels the breakdown of the key
in early Modern music. In theater, the proscenium
arch was breached as radically by Aristophanes (who
once had the actors throw water and wheat chaff on
the audience in the middle of a play) as by Vsevolod
Meyerhold. Socialism grew, meanwhile, until in
Pericles' Athens the state was the leading employer.

Then, as now, Modernism arose in the context of
a positivistic democracy carried away by emerging
international hegemony to an almost giddy sense of
its ability to solve social and cultural problems.
Thus, certain of the future, a culture gives away its
past. Traditions that developed over centuries or

millennia are discarded almost casually on the historicist assumption that something better will inevitably replace them. The intellectual origin of this activity was in the work of the Sophists, who are the first humans on record for stating publicly that convention is not a binding law but a material for us to shape as we want it. For our period, Hume and Voltaire and the other thinkers of the Age of Reason served that function.

The innocent confidence that the Modernist imperative requires ended, in the Greek case, with the catastrophic loss first of hegemony, then of self-rule. In the age that followed, called the Alexandrian, the tradition of the new was reversed. The idea of solving (and hence posing) one more formalist problem was no longer inspirational. The inner imperative of Greek art and culture turned toward its past. While it was not possible to regain in all innocence what had been sacrificed to the Modernist impulse, it was possible, through quoting, to enter into a new relationship with it. Theocritus wrote in the dialect of Sappho—which he had never heard; his readers were expected to recognize the allusion as a foundational content in his work. In time, new literary genres arose that featured quoting, like the "Scholars' Conversation," in which learned people play an intricate game of responding quotations and allusions; and the *cento,* a poem that was made up entirely of lines quoted from other poems. A huge industry arose in copies of great classical statues.

A period in which traditions are destroyed is apt to be followed by a period of nostalgic longing for

them and attempts to reconstruct them. The guilt of having destroyed them is allayed by incorporating them into the very context of their destruction. It seems clear that we are involved in an experience that parallels to some extent that of the Greeks. Similar value judgments have been rendered in both cases. The Alexandrian age is often regarded as one of exhaustion, as a time when Greek culture replayed the elegant achievements of its past, arraying them as a last review of antique riches before giving up the ghost. Post-Modernism, too, has been decried as a failure of nerve, a submission of free will, an abortive termination of a project that was not yet complete. But what could it mean for a project based on institutionalizing change to be "complete"? The idea that cultural history is inherently dominated by an arc of progress is a form of disguised millennialist historicism which is, really, a superstition. The great superstition of the post-Sophistic Greek culture was its faith in the efficacy of reason as an engineer of social change; in our time this superstitious faith has been redoubled by the religious overtones with which Darwinism has entered into ideas of social and spiritual advancement. The puritanical urgency of the Modernist imperative was based on hidden residues of mythic structures which still carried with them the intensity of divine promise. Clearly, progress has been expected to produce, in time, a human condition so improved as to be virtually Edenic: a state so good that the idea of further progress becomes inconceivable. One thinks of those prophetic cults that have expected the Millennium (or the Revolution,

or the Aquarian Age) to arrive within a few days, years, or decades. In this sense Modernism was yet another disguised form of the Christian prophecy of the End of History (which is striving), and the attainment of the ahistorical Edenic paradise again (as reward for that striving).

If we are to derive a beneficial lesson from this our Alexandrian time, it will be in part by paying attention to what it reveals about the delusions of our Modernism, and about our own ability, or eagerness, to be so deluded. To do so, one must relate to quotations as a type of content. The flaw in Modernism was precisely its conviction that it was not quoting and varying, but creating. Seen in this larger context, Alexandrian or post-Modern quoting is simply a process of bringing out into the open what all modes of expression do all the time anyway, but without usually bothering to acknowledge (or even realize) it. Quoting is an inevitable component in all acts of communication; it is what makes communication possible. Communication operates upon a foundation of habits; that is, codes shared between the senders and receivers of messages. Every message thus is a quotation or allusion to the whole mass of past messages in the same code, which have established the habits of recognition. To speak without quoting would be gibberish—or rather, it would not be speech at all, but sound, like wind or waves. Communication not based on quoting is a mythic ideal, like the innocent eye; both are fragments of the myth of Eden, of an ahistorical condition in which, since there is no historical sequence, everything hap-

pens, as Breton said of the unconscious, "always for the first time." One thinks of the Medieval experiment in which two children were raised without ever hearing language, to see what language they would naturally speak—which was assumed to be the language of Eden. Of course they spoke none, having been given no examples of one to quote. In the beginning was the Word—and since then there's been the quotation.

In most acts of communication, the quoting level is in the background; it functions almost invisibly, the better to foreground the specific present message. But when Theocritus quoted Sappho's dialect and meters, when Duchamp quoted the *Mona Lisa,* when a contemporary painter quotes Alexander Rodchenko or Francis Picabia, Jackson Pollock or Yves Tanguy or Andy Warhol, with full certainty that the quotation will be recognized, the relationship is directly reversed because the fact of quoting is placed in the foreground.

It is no surprise that such activity should be common in cultures that, like ours or that of Alexandrian Greece, have opened their receivers to the sign-systems of foreign cultures; such an experience either teaches one the relativity of one's own values and codes, or produces a xenophobic reaction designed to avoid that realization. Both modern Europe and Alexandrian Greece focused special attention on the semiotic impersonality of cultural expression. The Greek rulers of Egypt, for example, in a hypersophisticated act of political manipulation, created for the native proletariat a new religion constructed

cold-bloodedly out of extant symbolic codes. In our time, Roland Barthes expressed the impersonality of semiotic transactions as "the death of the Author": it is not an individual who speaks, he said, but Language that speaks through the individual. In the same sense, it is not the individual who makes images, but the vast image bank of world culture that images itself forth through the individual. That image bank (like language) can be viewed as a vast transpersonal mind aimlessly and relentlessly processing us through its synapses. To that extent, art based on quoting postulates the artist as a channel as much as a source, and negates or diminishes the idea of Romantic creativity and the deeper idea on which it is founded, that of the Soul. If we feel an ethical resistance to quoting it may be because we hold too dear the idea of Soul, because we cherish an essentialist prejudice about what art *should be*. At such a moment one thinks of Wittgenstein's advice to *look and see what it is*.

Despite its apparent disparagement of the idea of an integral self, quoting is an art mode in which the artist's intentions are brought into unusual prominence. Allusion, for example, always involves awareness of the artist's intention to allude, rather than to plagiarize. Irony, also, which must be an ingredient in most works of this type, involves a judgment about the artist's intentions. The old feeling of the leap of the artist's insight is not gone, but considerably altered in range and relevance: that leap is now a meta-leap, made up of the ruins of past leaps. Quotational painting is addressed as much to

the mind as to the eye. The idea that intelligence should be in an antagonistic relationship to the senses is an abomination, like all Manichaean-type dualisms. The dualisms of form and content, spirit and matter, mind and body, are all really the same dualism, one which arose in part as an archaic propaganda system to support an unchanging form of the state. As a second-generation form of conceptual art, this recent painting cannot be regarded as painting pure and simple in the old sense. If this is understood, Duchamp's phrase "stupid as a painter" will not apply; alternately, if the work lacks the kind of intelligence appropriate to it, it will be student work, or primitive work, or spurious. Further, since wit functions by a substitution of expectations, by a simultaneous invoking and denying of conditioned responses, it is potentially a means of insight into conditioning. The semiotic sensing involved produces a means of locating or defining the present, that is, oneself. When an artist quotes a familiar icon from the past in a clearly contemporary work, we sense semiotically the difference between the Then and the Now of the work and at the same time the relationship between them. That relation locates our present stance with a sometimes uncanny precision, which yields a subtle strangeness and an actual pleasure in the mind's tasting and appreciating of it. We sense the refoldings and redefinings of the vast image bank of all cultures and its creators. To this degree it is our own aesthetic habits that are held up as objects of contemplation in these ideograms of the history of taste.

A key function of this contemplative/critical regurgitation of images is to replay or reconfront the problem of abstraction, or, to call it by the other side of the coin, the problem of representation. Oddly, though our artists explored the interfaces and relations between these modes for nearly a century, neither they nor we were able to see clearly what we had to see: that representation is not representation and abstraction is not abstraction. Quotational art places the historical repertoire of art styles into the realm of nature, not in the sense that they are treated as laws of nature, but that they become simply more objects occurring on the screen of consciousness. The various styles that once were thought of as either representational or abstract may now be seen as neutral data which, according to convention, may be viewed as either this or that. The very distinction between representation and abstraction was an artificial convention: all image codes are neutral in this respect, until we project onto them one value or the other. What is being demonstrated is something about convention, and something about habit.

One of the great discoveries of our time, as of the Sophistic age in ancient Greece, has been the discovery of the neutrality of information. At its most effective, quotational work directs us toward this realization and brings us face to face with our own internal resistance to it. It focuses our attention less upon the images themselves than on our odd feelings about them, which have been made strange—and thus made visible—by achronological structuring. Our habit-expectations about temporal succession

(and thus about history) are defined by the atemporal image-cluster. To the extent to which that atemporality, or ahistoricism, seems strange or unacceptable, to that extent we are still controlled by the old habit-expectations. Those expectations were based on a false conviction of our own innocence; our ability to see innocently, to see "always for the first time," is affronted by the quoting process, as is the ultimately myth-based conviction of a historical inevitability. The confrontation with one's sense of the strangeness of it offers a glimpse of freedom, as we see that our expectations, our history, our selves, are all artifacts thrown off by infinite regresses of quotations, and that finally, freed from the myths of innocence and inevitability, we may do with them whatever we want.

If ever the search for a tranquil belief should end,
The future might stop emerging out the past,
Out of what is full of us; yet the search
And the future emerging out of us seem to be one. . . .

. . . The way through the world
Is more difficult to find than the way beyond it.

"I Am," Is a Vain Thought

*"I am" is a vain thought; "I am not" is a vain thought;
"I shall be" is a vain thought; "I shall not be" is a vain
thought. Vain thoughts are a sickness, an ulcer, a thorn.
But after overcoming all vain thoughts one is called a
silent thinker. And the thinker, the silent one, does no
more arise, no more pass away, no more tremble, no
more desire.—Majjhima-Nikaya 140*

*Robot Robert knew he was a robot, knew he was pro-
grammed to know it, suspected he was programmed to
rebel against it. Question: how can Robot Robert bust
his program with full assurance that he has not been
programmed to bust it?—Marv Friedenn*

Ankebuta, an ancient Babylonian scientist, wrote
a work on "artificial productions" in which he
claimed to have manufactured a living human be-
ing.[1] Babylonian culture, which did without the idea
of a soul, assumed that by meticulous imitation of
natural processes humans could create plants, ani-
mals, and even other humans (i.e., they "foresaw"
genetic engineering). The Hebrew cabalistic texts in
which the story is preserved do not allow it a happy

105

ending; it emerges not as a tale of scientific triumph, but of theological shame. Ankebuta's homunculus, we read, had neither speech nor locomotion, but could only open and close its eyes. The poor creature was doomed to inadequacy because the act of creating it was an affront to God. The moral is that only God can create a soul; any being not made by God must be soulless and, as a consequence, horrible. Similarly, the golem, a being created by a rabbinical successor of Ankebuta, was a general affliction to all who had contact with him, and a terrible omen for human destiny as a whole. The later monster of Dr. Frankenstein was represented as brain-damaged for the same hidden theological reason Ankebuta's was; the attempt to create a person is always perceived as impious in cultures that have a myth of the soul. Monotheistic religions feature this kind of anxiety especially.

A case from Greek polytheistic mythology—that of Asclepius, a human physician who became so skilled that he brought a patient back from death— provides instructive contrast. For this overstepping of mortal power Asclepius himself had to die, but after his death the gods admired his skill so much that they made him one of them; he became the god of medicine. Within the loose and shifting structure of a polytheism, with no idea of a fixed soul, and the conception of a changing universe, there was room for new deities of science.

Today the question of the self can be clearly focused by its relation to artificial intelligence. The issue, for example, of whether computers do, or will,

"think like people" has become a cutting edge to divide those who believe in the soul from those who do not. Yet the question of whether computers—or stones, or plants or homunculi—think like people is unanswerable until we know how people think—and so far we don't. Perhaps for this reason Alan Turing, a cyberneticist involved in the early development of computers, regarded the question as meaningless.[2] Still, the question whether human minds have possibilities that other systems can never attain has elicited much passionate debate, because it is, finally, a question about what it is to be a human being.

For some, humanness is a process that achieves definition, if at all, only by happening; like Heraclitus' river it may never be defined, for it may never be the same for two moments in a row. For others, humanness is a metaphysical essence that persists and remains the same, outside the flowing stream of nature. To this latter group the homunculus or robot seems an ontological perversion, a thing which, merely by existing as itself, diminishes us in what we are: it is a sign that the fall from grace is still tragically in progress. A recent advertisement in the *Houston Chronicle* for a Baptist church identified the computerization of society with the devil's campaign against the human soul.[3] The same case, but in milder terms, was made in a letter to the editors of the *New York Post:* "Concerning *Time* magazine's Man of the Year Award: to substitute a computer for a human being is an insult to those of us whose feelings and emotions run deeper than a 'mechanical object'."[4]

Presuppositions about the self fall mostly into three categories. In a purely phenomenalistic approach, the self is seen as a constantly changing stream of impressions and thoughts with no apparent unifying principle. Even the body is not acknowledged as a ground of unity (or substrate), because what we experience directly is not a body, but mental impressions that may (or may not) be interpreted as evidence of a body. For David Hume, for example, our experience is a stream of ever-changing "point-instant events" with nothing that may be regarded as a unifying principle. Seen in this way, the self is not a perceived object, but a mental object, created by an organizing operation performed on a stream of impressions which in themselves lack such organization. As Hume said, "What we call a mind is nothing but a heap or collection of different perceptions."[5] From this heap of random images a sense of personal identity is constructed.

Other thinkers recognize the existence of a body as a temporary substrate for the sense of self. From the time of Democritus, materialist thinkers have taught that consciousness is a temporary by-product of the combination of chemicals in the body. When certain molecules are combined in certain ways, a kind of "buzz" is set up that experiences itself as consciousness; in fact, since it is centered in a body, it experiences itself as a finite center of consciousness, or subject. When the molecules in question are separated by bodily death, the self simply ceases to appear to exist. This view, which is found also among Asian materialists such as the Carvakins, harmonizes

well with recent discoveries about the chemistry of emotion, memory, and other elements of the traditional self.

Still other thinkers have made an additional evidential leap beyond the body, to the existence of something (a soul) that is not dependent either on the steam of impressions in consciousness or on the chemical combinations in the body. This soul, being somehow outside the changing finite body and mind, will survive them both. This type of view, which may roughly be called Platonist, is found primarily in the Western monotheistic religions among the soulists, as Douglas Hofstadter has called them.[6] Modern American culture has inherited the Platonic-Christian concept of eternal soul as its most common presupposition about the self; the idea of the unique value of the individual and his or her ethical and aesthetic decisions is a somewhat secularized version of it.

In Japan the situation is quite different. Japanese culture is based to a large extent on the Buddhist idea of not-self, or soullessness. This traditional Buddhist view, which is formulated most extensively in the Abhidharma texts, is relevant to any comparison of Japanese and American attitudes toward robots and the self. The Abhidharma analysis of human mental processes operates through direct introspection; meditational practices are used to slow down the time sense until the flowing stream of consciousness can be studied. The procedure is essentially a positivistic use of what our culture calls ESP. What is reported by those who have mastered the microscopic appre-

hension of time is that the self is a series of discon-
nected atomic moments of consciousness that run
through so fast that they blur into an apparent con-
tinuum. Hume's "heap of perceptions" is a close par-
allel; even closer is the phenomenon of persistence
of vision that makes a series of still photographs,
when run through a projector at a speed too fast for
the eye to refocus on each one individually, appear
as a continuum of movement.

The idea of a self then "arises from a false atti-
tude," as Lama Govinda puts it. What we regard as
an enduring and unified center of subjectivity is "not
. . . a constant . . . 'thing' but an ever-flowing process
. . ."[7] As Buddhaghosa put it in the *Path of Purifica-
tion:* "Perception of impermanence should be culti-
vated for the purpose of eliminating the conceit 'I
am.' "[8] The Buddha, who had gone beyond the con-
ceit "I am" to the realization of not-self, is portrayed
in early Buddhist art either by an empty chair or a
pair of empty footprints or both: the illusion of self-
hood is gone; "he" is not there. A Buddhist teaching
image portrays the self as a mechanical construction
which can be taken apart as easily as put together.
The self is said to be like a chariot which, when
disassembled, appears as two wheels, a seat, an axle,
and a pole; everything that was present in the chariot
is still present, but the "chariot" is no longer seen.

In this view, then, the human self is like a me-
chanically constructed device, a model that has much
in common both with Hume and with Cybernetics.
One remarkable correspondence lies in their views
of the rate of mental operations. The atomic con-

sciousness units, or "mind-moments," into which Abhidharma analyzes the apparent continuum of subjectivity are described as enduring individually for only a billionth of an eye-blink or lightning flash. If an eye-blink occupies about a quarter to a third of a second, we may translate this to three or four billion mental events per second. This apparent hyperbole is found again in the literature on computers. "Supercomputers" at present perform from 20 million to 400 million operations a second; Japanese-planned general purpose computers will soon perform ten billion operations in a second; American-planned computers designed for specific purposes will soon accomplish up to 100 billion mental operations per second. The Buddhist view of the self, in other words, while it is amazingly unlike our inherited Christian view, is similar to a description of a computer.

When our culture faces robotization, it faces a satanic and terrifying reduction of its selfhood. When Japanese culture faces robotization, it sees nothing that it has not been familiar with, and at home with, for centuries. In Japan, for example, a Buddhist Abhidharmic text called the "Heart Sutra" is generally ambient in the culture, as are texts like the "Our Father" prayer in ours. While the "Our Father" is a direct personal appeal for the safety of a self which will not escape from the consequences of its personal choices throughout eternity, the "Heart Sutra" expresses the not-self doctrine relentlessly and calmly. "Here in this emptiness," it says, "there is no form, no feeling, no perception, no impulse, no conscious-

ness; no eye, no ear, no nose, no tongue, no touch, no mind; no form, sound, smell, taste, touch-object, concept; no sight sense, hearing sense, taste, smell, touch or mind sense."[9] And so on. It is no surprise that a culture imbued with such doctrines does not feel its humanity threatened by robotization; Judeo-Christian faith in the soul, on the other hand, provides a solid barrier of resistance and paranoia toward artificial intelligence. In terms of Western history this unrest is simply a continuation of the faith-reason controversy that has been a keynote of Christian culture since the Middle Ages. The same soul concept that opposed Darwinism opposes artificial intelligence, and for the same reason. Darwinism suggests that humanness is not an ontological but an existential concept, not an unchanging essence but a discovery which is constantly being discovered; it is there precisely to be reshaped. For Darwinism the soul has evolved out of the stream of nature and hence is subject to being washed away and dissolved in that stream again; on the cybernetic analogy, the self was constructed, through an act of interpretation, by a finite intelligence which itself is subject to the quasi-mechanistic stream of natural events. Either view is intolerable to the fundamental soulist doctrine which underlies much of our culture.

But the situation is not a simple and clear East-West dichotomy. As certain areas of Eastern thought have paralleled the Western naturalistic view, certain areas of Western tradition have paralleled the not-self doctrine. Language analysis, for example, has been perceived very similarly in the two settings.

Ramakrishna, the famous 19th-century Vedantin practitioner, eliminated the words "I" and "mine" from his vocabulary, referring to himself only as "this." Ramana Maharshi, another Vedantin, felt that "the conceit 'I am'" could be dispelled by keeping the question *what* am I?" constantly before the mind. Ludwig Wittgenstein, not so unlike Ramakrishna saying "this" instead of "I," noted that one should not say "I think" but "There is a thought."[10] Gilbert Ryle was not so distant, either, when he referred to "the 'systematic elusiveness' of the concept of 'I.'"[11] "What we have to acknowledge," said P.F. Strawson, " ... is the *primitiveness* of the concept of a person."[12] Roland Barthes has argued that the modern liberal idea of "the prestige of the individual, of, as it is more nobly put, the 'human person,'" is a by-product of the distortions of a particular cultural moment, an empirical-rational disguise of the Christian soul, arising by way of the Reformation emphasis on personal faith.[13] To some extent, both the unreconstructed doctrine of soul and the liberal-secular version of it are losing their grip on Western culture.

In the West, certain intellectual currents of the 20th century have functioned in part as critiques of the self. Freudian analysis reduces the self to a conglomerate of impersonal warring forces: the ego, or conscious subject, is merely an emissary of a vast impersonal sea of genetic and infantile contents. Marxism reduces the self to an impersonal by-product of class forces: one's social position determines one's thoughts and feelings. Physics has blurred selfhood

into relativity curves, quantum leaps, and observers who cannot observe because they are really participants, caught up in the same shifting river that they are attempting to observe.

Modern biology also shifts the concept of selfhood from the category of substance to that of process. If a neuron alters in the brain every time we experience anything, then the self is a constantly changing thing like John Locke's sock (which acquired one patch after another till no fiber of it was the same: Did it become another sock? When?). Structuralism and semiology have brought about an apotheosis of language into a kind of transpersonal mind that renders the individual self trivial. Barthes, for example, insisted on "the necessity to substitute language itself for the person. . . . It is language which speaks, not the author. . . ." Language, as the ultimate speaker, both transcends and voids the self: "*I* is nothing other than the instance saying *I:* language knows a (grammatical) 'subject,' not a 'person' . . ."[14]

The traditional Western idea of the self as an unchanging essence is threatened in the face of all these critiques. Roman Catholicism made peace with evolution by declaring that God put souls into a certain male and female ape at a certain moment in early hominid development, these being, then, Adam and Eve. The soul, in other words, is removed from the process of evolution; it did not evolve along with the body but entered the species fully prefabricated and not subject to modification in the future. Evolution is declared simply irrelevant to the destiny of the soul. Thus modern religion defends itself from

science not, as once, by denying science, but, more cunningly, by declaring it irrelevant.

As the idea of the integral individual self has been reduced to some conditioned response or other (from DNA to bourgeois individualism), the related idea of personal godhead has been replaced by a variety of transpersonal selves, universal minds, or master-codes. Language, the collective unconscious, the Oedipus complex, the historical dialectic, natural selection, the double helix, all have acquired something of the metaphysical status of impersonal godhead. In these emerging post-theistic and post-self religions the individual person recedes as his or her free will is increasingly co-opted by the code. For a self which transpires through a melting and merging of intricate transpersonal patternings, the idea of freedom becomes ambiguous or even ironic. It comes to seem, as B.F. Skinner proposed, that freedom is what we call the way we feel when we do what we have been conditioned to do.[15] The idea of a special quest for freedom, for a point of view that would transcend all codes, gets tangled in an infinite regress of programs, as in the parable quoted at the beginning of this essay. The quest for freedom from frameworks becomes simply another framework. The self remains relative, and cannot escape into the absolute. Modern scientific thought, finally, has evolved a composite view of the self as a shifting ripple in the Heraclitean river, a view that has much in common with that of Buddhist psychology.

Specific arguments against the analogy between artificial and human intelligence follow a characteristic

pattern: one part of human experience is isolated as outside conditioned causality; it is then declared to be inherently free or irrational or innocent, and hence not replicable by mechanical analogues. This part, whichever it may be, is shifted to the center of the human self as a residual soul or trace of soul. Intuition, introspection, memory, aesthetic sensibility, and emotionality have all served as the centers of such arguments. Some, for example, deny intuition and original thought to computers, since they think only by proxy. The argument is blurred by at least one case of original mathematical discovery by a computer, and by ignorance of the workings of human intuition to begin with. Others have fastened on affect (or emotionality) as the essentially human trait, and have asserted: "No mechanism could feel pleasure at its successes, grief when its valves fuse," and so on.[16] This formulation begs the question by assuming that there is something nonmechanical to the emotive processes—an assumption that remains unproved. The metaphysical nature of the claim seems apparent in light of neurotransmitter research. There is no obvious reason why emotional processes should not parallel and be paralleled by mechanical models; on the chemical level, it seems that a parallel modeling is already partly available.[17]

To yet other exponents of the unique human self it is the perception of beauty that is the specifically and inalienably human trait. But the relativism of canons of beauty suggest that they too are conditioned by the ambient causal net. Erich Neumann, for example, has written of the extreme changes ob-

served in the images of female beauty through hu-
man history.[18] The sense of beauty, in other words,
seems to be involved in evolution as much as is the
sense of self. It will not serve as a foundation for a
Platonic absolutism of the soul. Since the sense of
beauty responds to external forces, there is no reason
why it should not parallel mechanical processes or,
for that matter, be caused by them. The belief that
the apprehension of beauty is unconditioned or pre-
ternaturally free harks back to the myth of Eden; it
postulates a residual level of innocent perceptiveness
still active in the human mind, still apprehending
things with Edenic Grace.

Nostalgia for Eden brings with it the sense that
continuity with the past is essential to selfhood, that
the self is only on a solid footing when rooted in the
past. Memory is then seen as necessary to human-
ness, and as a treasure threatened by the electronic
storage and recovery of information. To empiricists
in general, as much as to those who are nostalgic for
a golden age, memory is seen as a primary evidence
or constituent of the self. For Locke, for example
(who still represents the common-sense consensus
of empiricist thought), "If X remembers doing such
and such, then he is the person who did that thing."
For Carl Jung also the sense of personal identity
arises from the apparent continuity of memory. Al-
terations in the working of memory, then, are
viewed as assaults against the self and as a loss of
humanness. (The not-self point of view necessarily
reads these facts in reverse: for Patanjali, the memory
is not the trace of the self, but the self the trace of the

memory; the self, in other words, is a habit system built up entirely by memory, and waiting to be taken apart.)[19] What is at issue is not so much a sudden shift as a long-standing process. Technology has been altering our relationship to information and its storage and recovery all along.

Julius Caesar, in the *Commentaries on the Gallic War* (VI, 14), notes that the Druids preserved the strength of their memories by refusing to commit their traditions to writing. Memory, he says, is the defense of literature. In oral traditions the inherited texts were stored directly in the human person, merging with it somewhat like the "book people" of Ray Bradbury's novel *Fahrenheit 451*. The Romans, on the other hand, like us, remembered not information itself but where information was stored. Some experience this as a loss of essential humanness, while for others it is a potential nirvana of escape from the prison of the individual self with its burden of past and future. One person's enlightenment is another's dehumanization.

Related to the defense of memory is the belief that introspection or self-awareness is an essentially human trait, one that machines cannot incorporate. Introspection means that the mind is both self-knowing and other-knowing in the same moment: it knows a sensum and simultaneously knows its own knowing of the sensum. A machine, on the other hand, is seen as limited to retrospection; it assimilates a piece of information, then in the next moment remembers assimilating it. This model is very questionable, however. Gilbert Ryle argues that peo-

ple know their sentience through memory, not through simultaneous or layered awareness. (The Abhidharma agrees.) Simultaneous other- and self-awareness would lead to an infinite regress, he argues, the mind being conscious of a sensum and conscious of being conscious of it, and conscious of being conscious of that, and so on.[20]

Lacking in self-awareness, the machine is also seen as obstructive to our need for direct experience. It threatens to inculcate a kind of solipsistic circular-gazing in place of human gregariousness, change, and activity—ultimately, to replace direct human touch with indirect cold-screen abstraction. E.M. Forster presents this case in "The Machine Stops," a nightmare projection of computer-dread into a complete loss of human vitality and relationship. In Forster's vision of a machine-dominated world, emotion and impulse are blurred out by a "horror of direct experience" that is the unavoidable consequence of the addiction to abstraction on the screen. "The desire to look directly at things" passes from the world. "Cover the window, please," one character says to another; "these mountains give me no ideas." Finally, "People never touched one another. The custom had become obsolete, owing to the machine." Each person sits before his or her cool, dotted screen, energy passing in a self-enclosing circle from fingertips to screen to eyes to fingertips. Under the influence of the machine, the human being seems to have become as silent and still as Ankebuta's winking homunculus.[21]

But another comparison may be more appropriate

than that of the brain-damaged monster. The shift
of human activity toward sedentary information
processing (already, of course, promoted by TV) is,
like everything else, part of a long ongoing process.
In antiquity, people did not read silently to them-
selves, but aloud to one another. Cicero had a reader
who followed him around all day with the book in
hand; at any idle moment—in the street, in the bath,
at table—he would recommence the reading. Those
who were not, like Cicero, professional readers and
writers, read aloud to one another or to themselves.
Literature did not yet seem separate from the voice,
from the body, from the living breath (spirit); it did
not yet seem a silent world of abstraction into which
one might wander away from the world of sense and
relationship. The first person on record as having
read silently to himself is Augustine of Hippo's
teacher Saint Ambrose. Here is Augustine's descrip-
tion of it: "When he read, his eyes scanned the page
and his heart explored the meaning, but his voice
was silent and his tongue was still. . . . Often, when
we came to see him, we found him reading like this
in silence. . . . We would sit there quietly, for no one
have the heart to disturb him when he was so en-
grossed. . . . After a time we went away. . . ."[22] So
Ambrose sat silent with his book, lacking apparent
speech or locomotion, like Ankebuta's pitiful mon-
ster (was *his* heart also "exploring the meaning"?),
as isolated from other people as George Segal's com-
puter victim on the cover of *Time* magazine's "Ma-
chine of the Year" issue. The practice of reading si-
lently to oneself spread as a part of Christian devo-

tional practice, involving monkish silence and the attention of the heart. Now we all do it. (Has it made us less human?)

Forster's anxiety was that the machine would remove us from a commitment to direct experience, addicting us to abstractions. The replacement of direct experience by abstract signs is again a long historical process that cannot be apocalyptically concentrated into a single moment like that of computerization. In ancient societies, before weights and measures were standardized, time and space were regarded in terms of direct experience. Chinese texts use "as long as it takes to eat a bowl of rice" as a time unit; Vedic texts use "as long as it takes to milk a cow." Buddhaghosa measures distances in units like "the range of a stone thrown by a man of medium stature," and "the distance that a woman throws a bowl of water from her back door."[23] Meters and miles are dead abstractions in comparison with these. But has their use made us less human, or more? Isn't the question meaningless once humanness is seen not as an essence but as a process?

In addition to his nostalgia for a natural state, Forster expresses another powerful and widespread type of computer-dread: the fear that "The Machine," with its potential for detailed monitoring of people, could become a tool for authoritarianism, that it might, indeed, stimulate authoritarian regimes to arise. In "The Machine Stops," as in humanistic science fiction in general, the machine, through its home terminals, becomes an extension into the private realm of the attitudes and values of centralized

authority. This objection is weighty and significant; but again it is worth pointing out that an historical process is involved, rather than a single monstrous cataclysm. Virtually all technological advances in history that could be used to the advantage of power and authority have been so used. When iron smelting was first developed, its Indo-European inventors did not even pause to consider making improved ploughshares, but straightaway forged the iron sword and launched a campaign of conquest. The radio, the internal combustion engine, the airplane, the television tube, all have been applied to the extension and consolidation of power structures. The present confrontation with new technologies is not radically different from these past ones. The same vigilance is called for to be conscious of their applications.

It may certainly be argued that a belief in the integrity of the self and its potential for freedom is necessary for the defense of basic freedoms from authoritarian inroads. It is, after all, the individual who is moved to his or her own protection. But a soulist belief is in no way an advantage for the maintenance of freedom. The Buddha, while teaching not-self, instituted a society far freer and more open than that of the great states of his day; and it is precisely the authoritarian claims of the soul that have rendered Christianity and Islam among the most violent and repressive traditions in history. The belief in auratic selfhood is often the root of tyranny.

The various theological myths—of the soul, of innocence, of Eden, of a sense of loss through his-

tory—that fuel the anxiety about the survival of human Selfhood also lie, in inverted form, behind the opposite point of view, which looks forward to a sort of freedom or salvation to be attained through the age of space. From this point of view, the artificial mind seems an instantiation of the not-self preached by the "Heart Sutra." The computer's flatness of affect is seen as preferable to irrational human passions. In the art realm, Andy Warhol embodied the mythological aspect of this point of view when he said, "I want to be a machine." The half-million-dollar Andy Warhol robot under construction in Valencia, California, is the symbol of this mechanistic messianism. Warhol's interesting ethical reflections in *The Philosophy of Andy Warhol (From A to B and Back Again)*[24] show an aversion to affect that parallels that of some Abhidharmic texts. In Buddhism it is the "tendency to react by emotions" that is the source of unnecessary bondages.[25] Warhol bases his preference precisely on the assumption that machines are not tossed about by fluctuating affect as humans are. Again he shows a trend in our society toward something like the not-self doctrine of primitive Buddhism.

According to the Abhidharma, "disturbances by emotionality will be removed by changes in interpretation"[26]; the goal is to rearrange one's relation to language so that the metaphor of selfhood is not constantly presupposed in one's thought processes. Effects that the computer might be expected to exert on the language-emotion linkage are relevant here. Jean-Paul Sartre, in reviewing Albert Camus's

L'Etranger, originated the term "white writing" *(l'ecriture blanche)* for a style that is relatively de-anthropomorphized and stripped of metaphor. Barthes recommended the elimination of verbal gestures that aim at modifying nature (that is, interpretive gestures) on the grounds that they express "the approach of a demiurge."

As the goal of this purification of discourse Barthes looked toward a "neutral writing . . . a mode of writing which might at last achieve innocence" from ethical presuppositions, a writing that would realize that "expressiveness is a myth." Through a "transparent form of speech", "the social or mythical characters of a language are abolished in favor of a neutral and inert state of form."[27] Something like a neutralized speech is found in the extremely dispassionate and anti-metaphorical discourse of the Abhidharma texts themselves. Computer jargon also tends to bleach metaphorical color out of language; it has been described to me by an enthusiast as a "clean language," freed from anthropomorphism, as human feelings, for example, are reduced to the neutral status of "information." In the terminology of information processing—data, input and output, storage and retrieval, and so on—only the most basic and neutral metaphors remain, such as the spatial picturing involved in the term "data base." Like Ramakrishna saying "this" instead of "I," Alfred Korzybski argued for improving sanity by eliminating the verb "be" from our speech.[28] Computer talk, with its distancing of claims and metaphors, may

itself go some distance toward bleaching soulism from speech.

In fact, the computer screen may have a tendency to bleach metaphor and affect from information. Books are different plastic objects; when rare or prized they are auratic, with all the implications for selfhood and objecthood involved in aura and fetishism. But on a readout or printout every text looks the same. The cathode screen, with its low resolution, small image, and impersonal format is a cold medium compared to the electric typewriter.[29] As the word-processor spreads among writers, it is not unreasonable to expect something like the "enormous changes which," as Walter Benjamin said, "printing ... has brought about in literature...."[30] Again what is in question with nostalgia for the book as a unique object is not a single event but an historical process. The hand-copied parchment book was far more unique and auratic than the printed book. Such nostalgia leads ever further back into history because fascination with the unique object is another disguised Edenism. Robert Graves has said that he writes poetry only in a room where every furnishing is handmade. The gesture expresses a belief in a primally innocent level of human character, as does Forster's dread that the machine will separate man from nature. In this respect the concept of self functions in art much as it does in religion, rather than as it does in science and philosophy.

Questions of the originality and authenticity of the auratic artwork depend on the belief in the integrity

and creative freedom of the self that produced it as a trace of soul. The abstract expressionist phenomenon was especially dependent on this Romantic (ultimately Platonic) view of self. But the art that followed it, epitomized symbolically in this respect by Warhol, seemed to accede to Benjamin's prophecies about the age of mechanical reproduction. Indeed, the division into crafts-arts and technician-mediated arts may to some extent reflect the divided or shifting attitude toward the self.

The Warhol robot again seems to symbolize the denial of the Romantic belief that art and science are opposed forces or sensibilities. (Of course, Warhol's works are themselves auratic in a pale, vampirical way.) The acceptance of a scientific relationship to aesthetics expresses an acceptance of the idea that aesthetics is not a fixed absolute but a dependent in the causal net. This view, in turn, may be seen as despairingly tragic by those committed to the belief that aesthetic canons are objective and unchanging in their essentials.

Henri Poincaré wrote that in mathematics "the useful combinations are precisely the most beautiful." Werner Heisenberg talked of science proceeding by "aesthetic criteria of truth."[31] But clearly Graves and Forster, in their nostalgia for the culture of the handmade object, will not be enticed by demonstrations of, say, the aesthetics of molecular structures in plastics. Graves and Forster (and many others) in effect adopt the myth of the Golden Age and locate humanity's "true" self in the past; Poincaré and Heisenberg imply instead the myth of the mil-

lennium, and locate the "true" self in the future. Surely the computer does diminish the past before the future: the Loeb Classical Library, a repository of more or less all the literature that survives from ancient Greece and Rome, could be entirely stored in a compact disc held between one's fingertips.

The myth of the millennium, which colors much of the positive feeling about computers and robots and a labor-free society, is bound up with the mythology of space and of salvation arriving from space. As our culture approaches the second Christian millennium, the myth of the promised return of the messiah from the sky becomes translatable into increasingly popular forms. A full-page newspaper advertisement that appeared around Christmas of 1982 across the country shows E.T.'s long, froglike finger reaching from outer space to touch a human hand, with a glint of light at the contact point. The take-off of the Sistine ceiling says simply that E.T. is God: from extra-terrestrial beings will our salvation arrive. Part of the great appeal of the movie *E.T.* is its hidden rearticulation of the ancient mythic structure of salvation from the sky. This myth first clearly appears in the Egyptian afterlife texts in which the soul of the deceased pharaoh was believed to ascend, after death, to the zone of the circumpolar stars, there to reside as a perfected being forever. It appeared again among the Orphics and, through them, in Plato; it is part of Plato's "Egyptianism" (as Nietzsche called it) which passed into Christian theology. In the Orphic-Platonic form of the myth, a being from the sky descends to earth, reveals the

destiny of the human soul as residing not on the earth but in the sky, then returns to the sky, showing the way to others who will strive to follow. Jesus is a representative of this mythic type, as is E.T., who is in fact patterned on Jesus as much as on Peter Pan. He is a youngster of his own species because he echoes Jesus, the Son, not the Father. Like Jesus inviting little children to come to him, E.T. communicates his message primarily to children. "E.T. phone home" is the vade mecum, the call to return to primal perfection in the sky.

This mythologizing is of course another form of disguised soulism, welcoming the shining-faced messiah with the keyboard as another brand of soulists reject it. The implication that this world, the Earth, is inadequate and imprisoning is again in the mood of Plato—and specifically in that mood for which Karl Popper called him an enemy of the open society.[32] Both the dread of technology and the expectation of salvation from it are irrational projections based on mythic structures. They are the stuff of theological disputes.

The degree of hidden metaphysics that still saturates the discussion of the self suggests the degree of anxiety it produces. This anxiety would seem implicated not only in dread of mortality and wishful projection of the self into an afterlife, but also in a concern for social order and the maintenance of class structure. The decentered self is out of harmony with a society still based on central authority. In the art realm, as elsewhere in culture, these tendencies toward centering and decentering are at the heart of the

tension between Modernist and post-Modernist modes. The former's emphasis on the purity and wholeness of the image is dissolved into the latter's chaotic overlays of discordant codes—as the self of the future stirs to be born.

NOTES

1. Christian David Ginsburg, *The Essenes: Their History and Doctrines; The Kabbalah: Its Doctrines, Development and History,* New York: Macmillan and Co., 1956, p. 158.

2. Cited by Douglas Hofstadter, *Gödel, Escher, Bach: An Eternal Golden Braid,* New York: Random House, Vintage Books, 1980, p. 597.

3. *Houston Chronicle,* February 9, 1983.

4. *New York Post,* January 3, 1983.

5. See Yoel Hoffman, *The Idea of Self East and West: A Comparison between Buddhist Philosophy and the Philosophy of David Hume,* Calcutta: Firma KLM Private Ltd., 1980, p. 40. The term "point-instant events" is Hoffman's.

6. Hofstadter, *Gödel, Escher, Bach,* p. 574.

7. Lama Anagarika Govinda, *The Psychological Attitude of Early Buddhist Philosophy,* New York: Samuel Weiser, 1974, pp. 80, 85.

8. Bhadantacariya Buddhaghosa, *The Path of Purification (Visuddhimagga),* English trans. by Bhikku Nanamoli, Kandy, Sri Lanka: The Buddhist Publication Society, 1975, p. 118.

9. The translation, which is quite literal, is my own. For the Sanskrit text and commentary, see Edward Conze, *Buddhist Wisdom Books, Containing The Diamond Sutra and The Heart Sutra,* London: George Allen & Unwin Ltd., 1958.

10. Wittgenstein was expressing his agreement with Georg Christoph Lichtenberg (1742–1799), who was in turn chastising Descartes. See G.E. Moore, "Wittgenstein's Lectures in 1930–33," *Mind* LXIV (1955), pp. 13–14.

11. Gilbert Ryle, *The Concept of Mind,* New York: Barnes & Noble, University Paperbacks, 1962, pp. 168, 186.

12. P.F. Strawson, "Persons," in *Essays in Philosophical Psychology,* ed. Donald F. Gustafson, Garden City, NY: Anchor Books, 1964, p. 388.

13. Roland Barthes, "The Death of the Author," in *Image, Music, Text,* English trans. by Stephen Heath, New York: Hill and Wang, 1977, pp. 143–145.

14. Barthes, "Death of the Author," ibid., p. 145.

15. B.F. Skinner, *Beyond Freedom and Dignity*, New York: Alfred A. Knopf, 1971, passim; *About Behaviorism*, New York: Alfred A. Knopf, 1974, pp. 54, 197.

16. G. Jefferson, "The Mind of Mechanical Man," *British Medical Journal* June 25, 1949, p. 1110.

17. For some work on mechanical/physiological modeling of memory, motivation, and emotion, see, e.g., Karl H. Pribram, "The Foundation of Psychoanalytic Theory: Freud's Neuropsychological Model," in *Brain and Behavior* 4, ed. K.H. Pribram, Baltimore, MD: Penguin Books, 1969, pp. 395–432; John C. Eccles, "Conscious Memory: The Cerebral Processes Concerned in Storage and Retrieval," in *The Self and Its Brain*, ed. Karl H. Popper and John C. Eccles, London: Springer International, 1977.

18. Erich Neumann, *The Great Mother: An Analysis of the Archetype*, English trans. by Ralph Mannheim, Princeton, NJ: Princeton University Press, Bollingen Series 47, 1955.

19. B.A.O. Williams, "Personal Identity and Individuation," in *Essays*, ed. Gustafson, p. 328; Carl G. Jung, *The Structure and Dynamics of the Psyche, Collected Works* Vol. 8, Princeton, NJ: Princeton University Press, 1969, p. 390; Patanjali, *Yoga Sutras*, IV.9: see the English translation by James Houghton Woods, *The Yoga-System of Patanjali with the Yoga Bhasya of Veda-Vasya and the Tattva-Vaicradi of Vachaspati Micra*, Delhi/Varanasi, Motilal Banarsidass, 1966, Harvard Oriental Series Vol. 17.

20. Ryle, *Concept of Mind*, p. 160.

21. E.M. Forster, "The Machine Stops," in *The Eternal Moment and Other Stories*, New York: Harcourt Brace Jovanovich, Harvest Books, 1956, pp. 11, 14, 13.

22. Saint Augustine, *Confessions*, English trans. by R.S. Pine-Coffin, Baltimore, MD: Penguin Books, 1961, p. 114.

23. Buddhaghosa, *Path of Purification*, p. 72.

24. Andy Warhol, *The Philosophy of Andy Warhol (From A to B and Back Again)*, New York: Harcourt Brace Jovanovich, 1975.

25. Herbert V. Guenther, *Philosophy and Psychology in the Abhidharma*, Berkeley, CA: Shambhala Publications Inc., 1976, p. 9.

26. Guenther, ibid., p. 11.

27. Roland Barthes, *Writing Degree Zero*, English trans. by Annette Lavers and Colin Smith, New York: Hill and Wang, 1968, pp. 51, 67, 69, 77.

28. Alfred Korzybski, *Science and Sanity: An Introduction to Non-Aristotelian Systems and General Semantics,* Lakeville, CT: The International Non-Aristotelian Library Publishing Co., 1933.

29. For elaboration of this line of thought see Jerry Mander, *Four Arguments for the Elimination of Television,* New York: William Morrow, 1978.

30. Walter Benjamin, "The Work of Art in the Age of Mechanical Reproduction," in *Illuminations,* New York: Schocken Books, 1969, pp. 218–219.

31. Henri Poincarë, *Science and Method,* English trans. by Francis Maitland, New York: Dover Publicatins, 1952, p. 59. Heisenberg cited in *On Aesthetics in Science,* ed. Judith Wechsler, Cambridge, MA: The MIT Press, 1981, p. 1.

32. Karl R. Popper, *The Open Society and Its Enemies,* Vol. 1, *The Spell of Plato,* Princeton, NJ: Princeton University Press, 1971.

Art History
or Sacred History?

Western civilization since the Roman Empire has been deeply split between its Greco-Roman and its Judeo-Christian aspects. Its cultural history has been shaped by an oscillation between the dominance of the one and the dominance of the other. The dichotomy is not complete, as elements of Platonism reside at the heart of the Judeo-Christian attitude, but it indicates very different value systems. The Greco-Roman tendency has been on the whole positivistic and critical, emphasizing doubt over faith and empirical investigation over inspiration. The Judeo-Christian thread has been generally transcendentalist and faith-oriented, with a tendency to denigrate reason and investigation in favor of feeling and intuition. One of these attitudes usually has the upper hand, and moments when they seem to mix more or less equally tend to end in confrontation. One such confrontation was the apostasy of the Emperor Julian and his party in the 4th century AD, resulting in the assassination of the emperor and the persecution of pagan intellectuals by Christian authorities.

Another was the faith/reason controversy of the 12th and 13th centuries, epitomized by the burning of Abelard's book analyzing the concept of the trinity. In both these cases the Judeo-Christian attitude triumphed and pushed the Greco-Roman aspect into the background for a while. An oscillation in the other direction began with the Renaissance, ushering in a steady ascendancy of the Greco-Roman aspect which culminated in the 18th century Enlightenment. This particular swing was characterized by increasing rejection or secularization of the idea of the soul, analysis of human selfhood into mechanical factors, and rejection of providential views of history. The next reversal brought into the foreground a resurgence of the transcendentalist ideology in the Romantic movement, with its rediscovery of the Middle Ages, its emphasis on the sublime and otherworldly, and its reintroduction of the faith-oriented tendency in the form of intuition and inspiration. Reason again was denigrated as inadequate to the task of knowing, and there was a powerful resurgence of belief in a great trans-historical soul held to be present both in human selfhood and in history. Unlike the Middle Ages, transcendentalist feeling in the Romantic period was not synonymous with established religion, which had been deeply wounded by the critical activity of the Enlightenment and never fully regained credibility. This failure was compensated in high cultural zones by a widespread belief in the transcendental powers of poetry and art, which were temporarily reinvested with traces of their archaic magical uses in order, as Matthew Ar-

nold noted, to buffer the shock of the dechristianization of Europe.

European Modernism was an extension of the Romantic period but with countercurrents. There is a transcendentalist Modernism involving the Romantic ideology of history and selfhood, based primarily on Hegel and post-Hegelian German metaphysics, and behind them on the long idealist tradition going back to St. Augustine and, more remotely, to Plato. This strain was represented in Modern art by the tradition of Kasimir Malevich and others whose concern was to approach the sublime and the absolute through art. The other aspect, which was in the background during the classical Modernist period, is a critical or skeptical attitude based partly on pre-Romantic sources such as the French *philosophes,* partly on post-Romantic ones such as the British analysts, and ultimately on the many Greco-Roman forebears of both those groups. It is represented in the Fine Arts by the tradition of Marcel Duchamp and others whose goal was to demystify the art experience and root it in conditionality.[1]

In Modern art generally the transcendentalist aspect has dominated, but since roughly 1970 the critical aspect, in the background since the end of the 18th century, has moved into the foreground again, where it has been called post-Modernism. Post-Modernism, seen in this broad perspective, is a renewed realization of the Greco-Roman aspect of our inheritance. It is, in other words, not an absolute end of an age but merely a return of an oscillation that has returned many times. Use of an apocalyptic term

such as post-Modernism, which suggests the absolute ending of one age and the absolute beginning of another, is a kind of wishful thinking, an attempt to exorcise the ghost from the machine once and for all. It may be that the ghost will not go without taking the machine with it.

The apocalyptic mood in which our Modernism and post-Modernism have been viewed has obscured the fact that there have been earlier Modernisms and earlier post-Modernisms. A Modernism is a cultural period characterized by two mutually supportive and mutually validating views about history and self-hood. 1) History seems to have an upward inner directive, a driving force of progress operating within it. In such a situation, innovation and change come to be valued over the stabilizing influence of tradition. There is a sense of confidence in history, which seems to be on one's side. 2) Validated by the inner purpose of history, the self inflates. There is an apotheosis of will and personal creativity, as the sources of historical change. Self-expression and originality are revered as the expressions of history's inner directive. There is an heroic view of the self as adventurer, innovator, and guiding force of history. A post-Modernism, on the other hand, is a period when the Modernist faith in history has been lost, usually through political developments. The support of history's inner meaning being withdrawn, the self deflates. History now seems to have no shape and the self no anointed mission. There are attempts to re-establish connections with the traditions destroyed by Modernist innovation.

The earliest Modernist period on record—though perhaps not the earliest in fact—is that which followed on the crystallization of the idea of progress in Greece in about 600 BC. This idea, of course, is by no means common in the world's history. Traditional societies have generally held a view of time as cyclical, with a degenerative direction within cycles: the myth of a descent from a Golden Age. It is regression, in other words, rather than progress, which is seen as the indwelling law of history. The ancient Greeks, in their epic period, had this myth of regression. The first extant expression of the opposing and revolutionary idea of progress is from the philosopher Xenophanes, who, in the 6th century BC, wrote (fr. DK B18):

The gods did not reveal everything to people at the beginning, but people, through their own search, find in the course of time that which is better.

Xenophanes presents a positivistic view in which progress is bound up with empirical method or investigation. It stands in sharp contrast to the views of traditional societies, in which it is believed that the gods did indeed reveal everything at the beginning, that the ways to do things are eternal, not subject to adjustment through research. By the 5th century BC the myth of the Golden Age had been replaced in Greek thought by a view still held today, that early human groups lived rough and brutish lives from which they gradually ascended to civilization through a progressive development and exercise of

skills. Progress, in other words, was the ruling principle of history.

Within the century after Xenophanes' statement the outlines of a fully developed cultural Modernism can be seen. By about 530 BC a clique of Athenian potters and vase painters had begun to sign their work, presumably in emulation of what panel painters were already doing. The completely unprecedented practice of signing artworks indicates the characteristic Modernist idea of art as a form of self-expression rather than as a validation of ancient ways. Artists such as Amasis and Exekias expected their audiences to recognize the signatured elements in their styles, to appreciate development within their oeuvres, and to place them in competetive hierchies based on value judgments dealing with their individual sensibilities. Whereas in ancient Egypt art had been an inherited and anonymous profession precisely on the same status as the traditional crafts such as weaving and carpentry, in Athens by around 500 BC art had separated itself from its social matrix and become a chosen vocation expressing an act of special personal will. Picture galleries began to appear, for the first time on record, where artworks were exhibited with no ritual or religious or magical aim, for no purpose other than aesthetic delectation. Histories of art came to be written, such as those by Xenocrates and Antigonus, that, like ours, dealt only with formal developments and valued innovation or originality. The history of art was assumed to be one of progress; the arts were traced from a "rude antiquity," as Pliny says (*rudis antiquitas,* NH 34.58), to a

state of alleged perfection in the classical period. In Pliny's Latin the passages on individual artists often begin with the phrase *hic primus* ... , "he first did this or that."

These developments in the visual arts were paralleled in literature. Like the visual arts, literature in, say, ancient Egypt was a functional part of religion and magic, and a social bonding device, not a cultural activity undertaken for its own sake. The Homeric poems retained the elements of public ritual performance, anonymity of authorship, and communal rather than personal expressivness. In the 6th century BC, while the visual arts were being broken free from this functional matrix, literature also was reconceived, for the first time on record, as a means of self-expression. The subjective lyrical poem arose. In the 5th century BC in Athens the bookstore arose alongside the picture gallery. Private book collections arose as opposed to the priestly libraries of the bronze age. Greek poetry, at the end of the 5th century BC, underwent a breakdown of inherited metrical restrictions that parallels the development of free verse in Europe and America in the 19th century. Music underwent a similar breakdown of tonal or modal restrictions paralleling the increasing use of chromaticism in 19th century music. In drama the structural conventions of the genres broke down— lyrics increasingly appearing anywhere in the Old Comic structure, for example, no longer tied to the traditional places—and the proscenium arch was breached in ways often believed, in our time, to have been originated by 20th century avant-garde play-

wrights and producers—as when Aristophanes' players turned on the audience and threw first water, then wheat chaff, on them in the middle of a play.[2]

These events reflected a growing milieu of bourgeois democracy and mercantile capitalism. The traditional aristocracies justified their claim to privilege by an appeal to birthright. The emerging middle class, lacking a claim to birthright, countered with an appeal to individual achievement. The ideology of individual achievement in turn led to a new emphasis on the acquisition of private property, which alone could prove individual achievement, and the elevation of exchange value over use value. Swept up in this process, the artwork was broken loose from traditional matrices and commodified for exchange. Single paintings by famous artists such as Apelles "would sell," Pliny tells us, "for the value of whole towns" (NH XXXV.50), much as do the works of famous artists today. Pliny tells us of a painter named Boularchos who succeeded in selling at least one picture for, literally, its weight in gold (NH XXXV, 55–56). On the model of the coin (which had only originated shortly before) the artwork became a free unit of exchange value. Its use value, as magical ritual element, which had sustained it for 20,000 years, was lost as the artwork became a free item of exchange, made portable, broken loose from its bondage to sacred architecture, so that it could change hands freely. As the artists themselves became celebrities, so did famous collectors, such as King Juba II of Mauretania (fl. late 1st century BC), who also wrote a book on painting and painters.

This Modernism perished, or was altered into a post-Modernism, by the collapse of the social structure of democratic capitalism. In the Alexandrian Age, after the loss of the polis and with it of the faith in humanistic progress, a post-Modern attempt to revivify the traditions that had been destroyed by Modernist innovation took over. Epics were again written in the Homeric style, lyrics in archaizing imitations of Sappho's Aeolic dialect by poets like Theocritus who had never heard it; painters and sculptors set themselves to making copies of classical masterpieces—as many artists do today. This shift in attitude has recurred several times in history. In the late Roman Republic, for example—the age of the so-called "New Poets"—the arts underwent a kind of Modernist phase again, which again was shattered by the end of the bourgois social order and converted, in the Age of the Antonines, into a post-Modernist recapitulationism. Other examples from the world's history—including Asian history—could be arrayed.

In the early Roman Empire the poet Seneca, influenced by both Alexandrian post-Modernism and late Roman Republican Modernism, presented an interestingly ambiguous model of history[3] (found in other ancient sources also). Within a vast cyclical framework the principle of progress held sway. Anticipating countless Modern thinkers such as John Dewey, Seneca wrote (Ep. 64.7):

I revere the discoveries of wisdom and their discoverers. It pleases me to look at wisdom as a legacy left to me by many men. For me they have gathered up, for me they have labored.

May an even greater legacy be left by myself to posterity. Much remains to do; much will remain; and no one born even after thousands of centuries will be deprived of the chance of adding something themselves.

Not long after Seneca, the idea of progress acquired a hidden religious meaning by its merging with the Judeo-Christian idea of the millennium. St. Augustine, combining the Jewish idea of Sacred History with the Greek idea of natural growth, likened the human race to a single great being with a natural life cycle that would bring it by inevitable stages to a state of perfection on earth. Progress became a reverse form of the myth of the Golden Age, heralding the end of history and the restoration of Eden on earth. It was, in effect, a disguised form of Providence—nothing less than God working out his intentions, leading humanity to perfection at the end of history as Yahweh had led the Chosen People to the Promised Land.

The two versions of the idea of progress are very different in their broader implications. Seneca had said that even after thousands of centuries people would still find contributions to make. For him the idea of progress did not involve an end term such as a restored Golden Age. It was simply the human way of life, to be always tinkering with our situation. For St. Augustine, on the other hand, the laborious step by step improvement of the human condition is not the point. The idea of progress had meaning only as it was bound up with the idea of a complete and miraculous redemptive transformation, an end term or goal which transcended any conceivable achieve-

ment of social engineering. It was not tinkering (*bricolage*) but salvation from on high that was heralded. This form of belief in progress invites abuse in the form of claims, however disguised, either that a certain state or society is the end condition toward which all history has been striving, or that a certain leader or party (or art critic for that matter) knows the direction which things must inevitably take. Such an advantage is not taken lightly. The Catholic Church, for example, protected its position as the proprietor of the end-game of history by denouncing as heretical any view that denied the upward and finite shape of history—such as Averroes's teaching that time was an infinite continuum of successive moments rising and falling without any overall directionality or shape, such as cyclicity, regression, or progression.

The conflation of religious millennialism with progressive positivism grew in Europe in a series of stages. The conviction, originally religious, that progress is a working out of the will of god, that it is, in other words, a sacred history, was directly in the background of transcendentalist Modernism. By the 17th century it had become a self-justifying circular argument. In the so-called Quarrel of the Ancients and Moderns, for example, French Modernists argued in effect that Modern culture must be superior to ancient culture because, progress having been in operation, it could not be otherwise. Jacques-Benigne Bossuet, in his *Discourse on Universal History* (1681), presented secular history as governed by Providence, while excluding overt references to di-

vine interventions. This became a standard means of writing history in the West, including art history. By the 17th century it was widely believed that colonial conquests showed the superiority of modern European civilization over others; this apparent superiority invested it with the role of the vanguard to lead humanity onward into the Golden Age.

Transcendental Modernism was definitively formulated in the work of Hegel. History was to be seen as a story of the progressive self-realization or self-remembrance of transcendent spirit; the process would culminate, at the end of history, in the absorption of nature entirely into spirit. This can be recognized as a variant of a widespread ancient religious idea found in Orphism as the soul's release through self-remembrance, in Aristotelianism as the thought that thinks itself, or self-realizing mind, in Neo-Platonism as Plotinus's three hypostases with forces of emanation and return, in Vedanta as the transition from *saguna* to *nirguna brahman,* and elsewhere. Hegel combined this ancient idealist concept with the Christian doctrine of the millennium, making it a once-and-for-all cosmic drama rather than a cyclical recurrence. This Christological structure is openly acknowledged by his adoption of the trinitarian view of history—ages of the Father, the Son, and the Spirit—formulated by the Medieval thinker Joachim of Flores (of which the Ancient-Medieval-Modern system of ages is a superficially secularized variant). Hegel illustrated how susceptible of abuse this millennialist myth is when he declared the Prussian state of his own day to be the perfect end of

history. In the generation after Hegel, Auguste Comte based his theory of history on what he called the Law of Progress, implying that progress is a natural law, on a status with the law of gravity: as gravity always pulls things down, so progress always pulls history forward and upward. Hegel called history Work because it involved this shared commitment to progress.

This disguised version of Sacred History soon seemed to receive strong confirmations. Darwinism was received as a scientific proof of the idea that progress is inherent in nature itself, that it is, in other words, a natural law as Comte had believed. Herbert Spencer and others generalized Darwinism from biology to culture, since it confirmed the providential view of history that was already in place. In the atmosphere of the industrial revolution, with its apparent promise of unlimited technological advance, the transposition from biology to culture seemed self-evidently justified. Thus Darwinism, like ancient Greek positivism, was co-opted into Judeo-Christian sacred history. In the classical Modernist period this millennialistic idea of progress was taken for granted; it was simply in the nature of things. It was the essential way to think about history, and the essential value of civilization.

The dangers of this powerful and multi-faceted myth go beyond its susceptibilty to political abuse. The myth, by erecting an artificial bulwark between the protected zone of history and the neutral flow of time, conceals the fact that if history has exhibited periods of massive progression, it has exhibited peri-

ods of equally massive regression. The Greeks, in their Dark Age, forgot how to write, after having had that skill for centuries. The European Dark Ages were comparably backward movements in terms of the complex of properties which are called civilization. Natural time viewed on a vaster scale than history is even more deeply sobering. Consider the Permian Extinctions, an event that happened about 225 million years ago and that caused the overnight extinction of ninety percent of the species on the earth. In the face of such evidence contemporary biologists do not view evolution as a progressive force but as a neutral flow that has no value quality at all. The appeal to a so-called Law of Progress blurs awareness of the dangers civilization faces and the necessity of dealing with them without either natural law or providence on our side. Since the industrial revolution, for example, technological invention has been promoted unquestioningly, on the faith that since it is progress, it must be good. This blind or religious faith in progress has led us to the edge of the abyss.

The myth that history was a self-transcending process was applied with special fervor or intensity to the history of art. Following Plotinus (*Enn.* 5.8.1), Hegel regarded art as a series of intimations of the absolute, foretastes, as it were, of the ultimate reality toward which all history, under Western leadership, was said to be striving. Art, in other words, though it had a sensual body, was about transcendent and immaterial things. Along with religion and philosophy, art was a channel to the beyond, to the reality of transcendent spirit. Hegel's contemporary, Fried-

rich von Schelling, elevated art even beyond this, holding that it was able to point toward the absolute more directly than any other human means and was therefore intimately bound up with the progress of history and the realization of spirit. Art was both providence's instrument and its sign. Thus art history also became a variant form of Sacred History, with a hidden millennialist myth.

This idea was elaborated into a methodology for art history by Hegel's student Karl Schnaase, in 1834. Hegel himself had not proposed that art in particular embodied the force of progress; indeed, he felt that art had reached its apogee in classical Greece, and had been in something of a decline ever since. Schnaase, however, transposed Hegel's view of history as a whole into the limited sphere of art history. He argued that artistic development has an inherent purpose which transcends individual personality and social circumstance, and that this purpose is nothing less than history's great project of integrating nature and spirit till they become one. Art's destiny, he felt, is to lead humanity along this line of development. On this view it appeared that artists, rather than statesmen or founders of empires, must be the vanguard to Western civilization, the Chosen People as it were, as Western civilization was to the rest of the world. To devotees of this religion of art, the composer of the "Heroic Symphony" replaced the hero for whom it was composed as the "world-historical" individual who was leading history toward its goal. For Heinrich Wöelfflin a crucial artist like Titian was a "great individual," that is, a

Hegelian world-historical figure, guiding humanity toward the culmination of history.[4] In the writings of Johann Friedrich von Schiller, the artist and poet were elevated to the status of virtual deities, independent beings who were a law unto themselves, who, merely by practising their crafts, were already innocent, pure, and all powerful. This characeristically Romantic-heroic concept became and remains basic to art historical practice and also to the attitude toward their own work that many Modernist artists have held.

Artistic continuity, according to Schnaase, involved the resolution in the present of formal problems encountered in the immediate past. This series of problems and solutions comprises art history, which is the step-by-step self-realization of the absolute in visual form. Because of its connection with the absolute, artistic form was regarded as freed from the influence of changing circumstance. Hence social function and symbolic meaning were held to be extraneous. Artistic development, in other words, is not dependent upon changes in society or religion or anything else outside of its own formal means. Art floated above the social situation, in near communion with the beyond.

Wöelfflin elaborated the idea that the history of visual forms develops with an inevitable inner logic that is quite independent of external influences. He argued for two roots of style: an essential one which is purely visual, and an adventitious one comprised of social and other external circumstances. Though external influences, on this view, do leave an imprint

on the history of styles, this imprint is quite separate from the pure evolution of form. Properly understood, according to Wöelfflin, formal developments are "intelligible . . . as something coming into being necessarily," that is to say as essentially providential events, drawn out by the inexorable advance of history toward its goal.[5]

By the mid-19th century this view had taken over the discourse on art. Artists and art enthusiasts could speak of nothing but infinity. Hegel had said that art was an embodiment of the infinite (an obvious contradiction in terms). Schelling similarly felt that art was a resolution of an infinite contradiction in a finite object. The artist James McNeil Whistler, an exponent of the art-for-art's-sake attitude that developed from Hegelian artistic millennialism, remarked that "art is limited to the infinite"—that is, it is lmited to the unlimited. Vincent van Gogh wrote to his brother Theo, "I paint infinity." Countless other examples of this way of speaking could be gleaned from the art discourse of c.1800 to c.1960 AD.

This legacy of disguised providential millennialism hung heavy over 20th-century Modernism, like storm clouds of sublime and ominous portent. The formulation of the idea of progress in art in terms of the spiritual advancement of humanity was the fuel of the transcendental Modernist stream that ran through the works of Kasimir Malevich, Wassily Kandinsky, Piet Mondrian, Yves Klein, Lucio Fontana, Mark Rothko, Barnett Newman and many others. All these artists spoke of their work in the overwrought religious terms that go back to the age

of Hegel—its ability to embody the infinite in finite form, its purity and separation from the here below, its ability to lift the veil that lies before the realm of Platonic pure form—and many of them actually suspected that their works were the last physical artworks, the artworks that immediately preceded the absorption of matter into spirit. Less openly acknowledged by critics and historians than by artists, still this formulation underlies, at the level of presupposition, the essays of Clive Bell, of Roger Fry, of Clement Greenberg, of Sheldon Nodelman, and of many other formalist Modernist writers. When an art writer declared, for example, using the Hegelian terminology, that Jackson Pollock's paintings were "world historical in importance,"[6] the statement meant nothing less than that Pollock's works were leading the entire world (including the billion Chinese who would never see his work, the thousands starving in Ethiopia, and so on) toward redemption. The fantasy-like quality of this idea can hardly be exaggerated. The extraordinary mental and emotional pressures felt by many Modernist artists may have resulted in part from trying to live up to this archaic religious role, this messianic-prophetic responsibility.

The idea of progress in art history brought with it a constellation of other essentially metaphysical ideas. It implied, for example, some transcendent and unchanging criterion of quality, which alone could guarantee the consistency of progress. The Hegelian art historians did not formulate the ever improving quality of artworks in purely aesthetic

terms. Alois Riegl, for example, argued that every art style or period should be evaluated only by its own standards. Yet changes in different styles and periods were all regarded as expressions of a single overriding essence, ultimately of spirit itself. The real progress of art—its unfolding of pure spirit— was formulated both in the archaic spiritual terms used by Hegel and Schnaase and in an ostensibly more secularized version, originated early in this century by Riegl, which speaks not in terms of spiritual advancement but of cognitive development. Whereas artists have tended to favor the spiritual terms, critics and historians have tended to favor the terminology of cognitive advancement; but they are variants of the same myth.

In the formulation by cognitive development the discovery of linear perspective in the Renaissance was seen as a crucial step. In his book *Late Roman Art* (1901), Riegl argued that the ancients could not see as clearly as we can:

Their senses showed them external objects in a muddled and indistinct fashion; therefore in their visual art they isolated individual objects and set them in their clear circumscribed unity.[7]

Riegl is referring here to the so-called Polygnotan style of composition, attributed to the 5th century BC painter Polygnotus of Thasos, in which objects are not foreshortened or diminished in size by distance and do not overlap. To show objects diminishing in size as they grow more distant from the viewer is to give the viewer's subjectivity a ruling force in

the composition. In the Polygnotan style of composition, on the other hand, it is not the subjectivity of the viewer that is uppermost, but the integrity of the objects portrayed; these objects maintain their relative size regardless of distance and are arranged in a series of receding almost flat planes, more or less independent of one another, each as it were a new foreground plane. This mode of composition eliminates the subjective projection of the viewer—from which foreshortening and perspective arise—in favor of the wholeness of the object. Riegl felt that the ancients had no alternative to this mode of composition due to deficiencies in their cognitive development.

In this view of artistic progress the appearance of perspectival rendering in the Renaissance is revered as a centrally significant cognitive advance, a sublime leap of the soul toward its realization of pure subjectivity or pure spirit. This idea has had a wide circulation. It is found, for example, in Erwin Panofsky's paper of 1927, "Perspective as Symbolic Form," where Panofsky assumes that neither ancient geometry nor ancient pictorial depiction had a sense of the wholeness of space as container of both subject and object, and that this realization, which he equated with his own Neo-Kantianism, arose with Renaissance perspective.[8] In an earlier paper Panofsky, like Riegl, had singled out Polygnotan composition as an example of limitation of self-awareness, saying that Polygnotus could not have conceived the idea of painting a landscape, his mental world lacking awareness of the continuity of space.[9]

This schema reappears in Roger Fry's classic text, *Reflections on British Painting,* of 1934. Fry wrote (formulating the first half of the Western myth of art history):

The whole history of art may be summed up as the history of the gradual discovery of appearances [*viz, of the subjective point of view in vision*]. Primitive art starts, like that of children, with symbols . . . Gradually the symbolism approximates more and more to actual appearance . . . It has taken from Neolithic times till the 19th century to perfect this discovery [*of appearances*]. European art since the time of Giotto progressed more or less continously in this direction, in which the discovery of linear perspective marks a crucial stage, while the full exploration of atmospheric color and color perspective had to await the work of the French impressionists.[10]

In 1977, in her book *Progress in Art,* Suzi Gablik purveyed this view again, with supporting analogies from Jean Piaget.[11] In brief, she argued that the ancients' inability to make conscious the subjective projection of perspective reveals them as cognitively like children who, according to Piaget, conceive the world two-dimensionally before they can conceive it three-dimensionally. The supposed absence of three-dimensional renderings in ancient art is taken to show that the communal ego of those cultures was confused about its relationship to space, about space's extension away from the subject, its simultaneous separation and connection of subject and object. Humanity, then, grew up in the European Renaissance, with the discovery of space and the ego's place within it.

The prevalence of this view is peculiar, since the evidence has long indicated that perspectival render-

ings based on a single vanishing point in the depth axis of a picture existed in the art of the Greco-Roman world, as a part of the complex of democratic subjectivist Modernism. Vitruvius (VII, *praef.* 11) seems to attribute the discovery of the vanishing point to the scenographer, or stage designer, Agatharchus, in the time of Aeschylus, that is, before the middle of the 5th century BC. Stage design, which usually consisted of architectural facades, was the natural place for this development. From stage design the use of perspective passed into painting—not into vase painting, since the vase, with its convex outer surface asserting its presence, is not receptive to the illusion of deep space, but into panel painting and wall painting, two bodies of work that have mostly disappeared. The visual evidence is mostly in the remains of the Second Pompeian Style of Romano-Campanian mural painting. In a wall painting from the Corinthian *oecus* of the House of the Labyrinth at Pompeii, for example, the forty or so architectural parallels converge in a single vanishing point. In a wall painting from the Room of the Masks in the House of Augustus on the Palatine in Rome are even more architectural parallels, all converging in a single point. The same situation holds in paintings from the *cubiculum* of the Villa of Publius Fannius Sinister from Boscoreale, the architectural room of the Villa of the Mysteries at Pompeii, and elsewhere. The close connection of this style of drawing with architecture is not surprising; the architectural author Damianus strongly implies that the ancient architect made perspectival renderings of

his designs to show to clients. The evidence is that in the Second Pompeian Style we are not seeing a partly developed system of perspective but a partly deteriorated one.[12] In other words, perspectival representation, probably dominant from the 4th century BC, had begun to give way to a new convention in the Second Pompeian period. Not only was perspective a part of representation in the Greco-Roman age, it was a part which Greco-Roman painters, like Modern painters, had already gone deliberately beyond. Even atmospheric perspective, meaning such effects as when the light blurs into a misty distance, and so on, which Fry said had to wait for Impressionism, was a regular feature of Greco-Roman painting. Called *skiagraphia,* or shadow painting, and featuring the "fading out" and "building up" of shades of color "due to the position and texture of the object and its distance from the beholder,"[13] it was specially attributed to the Athenian painter Apollodorus, active in the last quarter of the 5th century BC. The mastery of "appearance" which Fry feels was the major achievement of European art, was already quite consciously articulated in ancient art criticism and, it seems, more or less achieved in ancient art.

The Greek theory of perspective survived in Arabic culture in books on optics, architecture, and cartography, and in the 12th century began making its way back into Europe. The greatest of the Arab optical treatises, Alhazen's *Perspectiva,* was introduced into the West about 1200 and was the basis of 13th century studies of optics such as John Pecham's,

which in turn was a text used by Leonbattista Alberti, who was the first European to write about convergence and the vanishing point. Alhazen's book alone would not yield fully the doctrine of convergence and the vanishing point, but it prepared the ground. Equally so did Vitruvius's book *On Architecture*, which was closely read in Florence in Alberti's day. Alberti's associate Ghiberti, to whom his treatise on perspective is dedicated, had the crucial passage copied out in his notebook. A third element in the diffusion process was the renewal of study of Euclid's *Elements*, from which certain fundamentals of perspective can be derived. The crowning event was the importation into Florence of Ptolemy's *Geography* by Manuel Chrysolaris in the year 1400. Ptolemy's instructions in that book for cartographic projections comprise a clearcut linear perspective system based on geometric principles and not difficult to transpose into the process of picture making. This book was widely read in Florence in the early 15th century, and was surely known to Brunelleschi, who in 1425 demonstrated the idea of the vanishing point, and to Alberti, who in 1435 in his treatise *De Pictura* gave instructions for perspectival pictures. The influence of actual ancient artworks on Renaissance artists also cannot be excluded. Though the ruins at Pompeii were not available, there are paintings with architectural orthagonals in the Golden House of Nero in Rome, which is known to have been visited by Raphael and others and may have been known as early as Brunelleschi's day, and in Hadrian's villa at Tivoli, which also was known in

the Renaissance. Although the evidential chain is not complete, the weight of it suggests that perspective was not discovered in the Renaissance but re-covered—as was the ancient style of painting in general.[14] If linear perspective means progress, then the overall shape of art history is not a single long arc of progress, as Fry thought, but an irregular up and down path, a picture of progress balanced by regress, of knowledge gained, then lost, then gained again—perhaps to be lost again, and so on.

The overall myth of Western art history runs, in simple terms, like this: with the Renaissance discovery of perspective the objective rendering of outer reality became possible, and over the following five centuries representation was developed in more and more perfect forms until mid-19th century realism and early Impressionism. At that time art, having perfected representation, was ready to transcend it, by its own inner directive or law of progress, and proceed from the mastery of nature to the mastery of the sublime and the absolute. The stage, in other words, was set for abstract art, which, in the minds of such as Malevich and Mondrian, was a final or very advanced stage in the self-realization of spirit. The art of the abstract sublime had no less a mission than heralding the culmination of history. The transcendent nature of this goal combined with certain problems in the presuppositions of art historiography to create a delusion of staggering scale.

A central problem was the question of origins. On the model of art history as a linked sequence of formal solutions and problems, changes in artistic prac-

tice cannot adequately be accounted for. Wöelfflin simultaneously and somewhat contradictorily hailed Titian as a "great individual" and denied that there was any break in continuity—i.e., anything new— represented by his work. George Kubler, in his influential book *The Shape of Time* (1962), attempted to deal with this problem through the idea of the Prime Object, which he defined as an object that cannot be broken down into its causes.[15]

Clearly some artworks do have the look, when considered purely in formal terms, of having risen out of nothing, out of the exhaustion of a past sequence that then leads to a creative break through the intervention of a world historical great individual. But this look is not scientifically explained by the idea of the Prime Object, so much as it is metaphysically enshrined. The "prime object" is a metaphysical idea based on Aristotle's Prime Mover, an entity that is uncaused, or self-caused, but which causes other things after itself—in other words, a miracle. This is the paradox at the heart of the formalist practice of art history: on the one hand the postulate of formal continuity, on the other hand radical breaks in the continuity wherein miraculous new creations arise from no particular causes. The contradiction is like that between scientific evolutionism and religious creationism. As the paleontologist Stephen Jay Gould put it for the biological sciences, "The notion of 'abrupt appearance'—the origin of complex something from previous nothings—resides in [the] domain of miracle and is not part of science."[16]

The reason a so-called Prime Object cannot be de-

composed into its causes is that one has not looked around widely enough in search of those causes. Kubler, following Schnaase, allows only formal causes to qualify. It is illuminating in this context to remember Aristotle's distinction among four types of causes. The tradition that we have been considering recognizes only one of Aristotle's four causes, the formal cause. Recent art criticism and art history have somewhat less enthusiastically admitted the material cause also into the art discourse. But the efficient cause—that is, the question, Who made it?—which opens up the whole area of autobiography and intentionality, is forbidden, as is the Final Cause—the question, What was it made for?—which opens up the areas of the social and political functioning of the artwork. By looking more widely for the causes of so-called Prime Objects, we might find them. They would appear to reside, at least in part, in Wöelfflin's second, and forbidden, root of style.

The belief that important examples of abstract art were essentially miraculous, that they were signs of the imminence of the millennial state of spiritual perfection, turned 20th century art history most intensely into a Sacred History. Around mid-century the sense of participating in a cosmic ritual got so intense that artists such as Ad Reinhardt and Yves Klein could feel prophetically that they were making the ultimate artworks, the works that marked the final absorption of nature into the spiritual in art, of which the next stage would be immaterial, or pure spirit.

This absurd *cul de sac* was the inevitable result of

the Hegelian-formalist interpretation of art history. In America the realization that art, through the hegemony of formalism, had come to be characterized by a kind of sinister death wish dawned in the late '60s. External circumstances—the war in Vietnam, the nuclear arms race, other things—had made the formalist doctrine about art seem not merely asocial but antisocial, not merely inhuman but antihuman. One can hear behind Clement Greenberg's "Complaints of an Art Critic," 1967, the trumpet of the angel of death calling the end to formalism.[17]

Greenberg's contribution to the Hegelian line which he practised (while calling it Kantian) was to drive out into the open the idea of quality and to fortify it by the hypostatization of taste as a supralinguistic disembodied faculty not unlike the eye of the soul in Plato. Between this quality and this taste an intercourse was said to go on that was strictly on Wöelfflin's first track, or visual root, of style, having nothing of the social or personal in it. In "Complaints," Greenberg, in a delirium of the ego inflation which results from the conviction that history is one's ally, made a last stand defense of the formalist theology. "Objective qualitative principles," he wrote, operated without complicity of the person. Their judgments were "involuntary." As a possessor of true taste "you relish the fact that in art things happen of their own accord and not yours." One hears here an echo of Wöelfflin's assertion that world historical works come into being inevitably—which itself foreshadows the Russian Formalist Ostrip's remark that Pushkin's *Eugene Onegin* would have been

written even if Pushkin had never lived, a remark which reduces the attitude to absurdity. With a tacit nod to Hegel, Greenberg explained that "works of art go beyond anything specifiable in their effect"— that is, to the Beyond—and the critic is carried away by "mere ungovernable taste," like a prophet of old responding to the divine afflatus. Desperately the last inheritor of the Hegelian myth tried to stem an increasing leakage from Wöelfflinn's second, illicit and worldly track into his first.

In recent art Wöelfflin's second track has stormed over the barrier and swamped the first. Not only are social forces recognized as formative on artworks beyond the level of the adventitious, but the inevitability of certain sequences of formal development— which was the essence of Wöelfflin's first track— seems a hollow naïveté. Contact with other traditions has shown examples of formal sequences which exactly reverse our own, and which cannot be called unnatural except by the elevation of our own cultural viewpoint to the status of a universal.

The Modernist myth that history had a certain shape which was inevitable and natural functioned to protect culture from nature, to separate it from the chaotic welter in which species rise and fall nightmarishly into nothing. History was a kind of potential space (in D.W. Winncott's sense of the term), a motherly embrace which separated one from the grim realities of nature. This separation functioned through the devices Levi-Strauss discovered in myth. The belief that biological evolution showed a teleological arc of progress parallel to that projected

onto (Western) culture has the effect of culturizing nature, making it seem on our side. The myth that certain ways of seeing were innocent, or unconditioned, like elements of nature, in its turn naturalized culture, giving to it the status of natural law.

From a post-Modern point of view both these strategies seem exhausted. History no longer seems to have any shape, nor does it seem any longer to be going any place in particular. History, in the post-Modern age, has dissolved into mere time, into Averroes's endless succession of moments without overall shape or direction. In the last few years artists have embodied the shift in attitude toward history in new artistic methods, new ways to relate to tradition. One sign of the post-Modern approach to history is the prevalence of quotation, as it takes apart the linear sequences of historical ages and conflates the Paleolithic wall painting, the Sumerian icon, the Egyptian monumental sculpture, the Ionic frieze, the Roman sarcophagus, the Baroque mythological allegory, the central classical Modernist styles and a good deal more. Quotational work takes art history apart and throws its deck into the air, to clear the field of myths of inevitability. The process of motif development that Gottfried Semper expressed as descent from an Ur-motiv (cf. "Prime Object") is reversed; the onrushing flow of the descent is arrested and the stages of the process are taken apart. The sequence of stages is deliberately cancelled and the authority of the Ur-motiv is collapsed into the Precession of Simulacra. The obsession with formal sequences made up of linked solutions, which formerly

seemed to imply a progress toward a goal, now seems merely an obsession. The feeling spreads that the series of linked solutions from the past add up only to an incoherent array of fragmentary arcs or arrows that, while pointing in all directions, lead nowhere but to now. Supplanting the authoritaian Modernist doctrine of formal inevitability, post-Modernism presents itself simultaneously as a permission to go anywhere, and as a realization that there is nowhere to go but here. It amounts to a return from the Christian-based transcendental view of progress to the pagan view expressed by Seneca, that it is a process that goes on forever and hence leads nowhere. Adrift on an ocean of time, there is no goal but there is still a way of going.

As the sense of history shifts, the idea of the self follows. The emphasis in the art of the 1980s on the fragment and the politics of the fragment is an iconographic denial of transcendent or heroic selfhood. It throws emphasis back upon the present as the only living moment, affirming the loss of meaningful purpose and continuity as a liberation. The entrapped and entrapping spaces inhabited by the figure in much recent painting shadow forth the constitution of the self by social circumstance. The elimination of the human figure from vast representational spaces expresses the loss of definition of selfhood, the uncertainty of what part it should, or could, or will perform upon the stage of the world. The lack of difference between the self and the world around it, the enmeshedness of the self in the general causal web, leads to the rejection of the fundamental

dichotomies abstract/representational and figure/ground. The aggressive conflation of the decorative with the artistic collapses the heroism of the artist back into the anonymity of the craftsperson.

Transitional art—the art that moves us from Modernism to post-Modernism—expresses the return of history into time and the dissolving of the self into the welter of species. In its attempt to break down the bulwark that separates nature from culture it denies the transcendent criterion of quality. To exercise value judgments of the old type upon it is meaningless. The point is now not one of formal originality but one of response to the ambient world moment. Every age has certain things which it needs to have said. Formalist art said them by the negative mode of pretending to transcend them. In the transition phase what were (and to a degree still are) needed were expressions that deny center-stage heroic originality, that express a curtailment of will, that deal not with the infinite but with limits.

As the faith fades that Western art transcends causality, so goes the sense of its special mission to lead the world into new triumphs of spirituality. To face the emerging traditions in the next decades we must first have shed our local tribal myth. To a great extent this is what post-Modernism is about—it is an opportunity to adjust our inherited myths into a frame of mind in which we may begin to embrace traditions other than ours on something like equal terms.

Without playing the prophet, one can feel sure that if history continues the near future holds a period in

which Orontes will increasingly flow into Tiber, as the poet Juvenal put it of the incursion of Eastern cultures into the Roman Empire. The cultures of the world will increasingly mix on sociological and economic levels. The question how they will mix intellectually and culturally becomes not only one of the great adventures for the art of the future to live through, it becomes a question of actual survival, or shall we say an aspect of the overall question of survival.

If a post-Modern practice of art history emerges and matures—and indeed the beginnings of one can already be seen—it will probably contain several types of studies that have been somewhat neglected by Modernist art history, alongside the characteristic Modernist types of studies, which of course have made great achievements. To begin with, there is no reason why the social history of art should be written only by Marxists, and this limitation will probably not survive much longer. Such studies may foreground the question of the function of art, a question that has been somewhat begged by the Modernist practice. Secondly, a post-Modern art history will rewrite the history of art in terms of content, as it has thus far been written primarily in terms of form. Only then will a third crucial type of study be possible, the study of the relationship between form and content, the question, for example, whether certain contents regulary bring certain forms with them, or the other way around, and how these conjunctions in turn are affected by social forces. Fourth, art history must be seen anew in

terms of its discontinuities rather than its continuities—the Renaissance and the emergence of abstract art, for example, being understood as major ruptures or negations in the European tradition—though past studies of them have consistently emphasized the aspect of continuity. Fifth, comparative developmental studies would perform a great service by relativising our own tradition, along with the diffusion studies that will be required as part of their method. Finally, rather than the Modernist obsession with assigning value judgments, a post-Modern art history would focus its analysis on the concept of value itself, through comparative studies of the idea of quality in different times and places.

NOTES

1. This is, of course, not a complete topography of the times. Though the transcendentalist aspect of Modernism is a disguised form of the Judeo-Christian tradition, it is not the extreme form of that force, which remains enshrined in pre-Modern cultural forms such as religious fundamentalism. For the Greco-Roman forebears of modern skeptical and deconstructive thought, see Thomas McEvilley, "Penelope's Night Work: Negative Thinking in Greek Philosophy," *Krisis* No. 2, 1984, pp. 41–59.

2. For more on this subject see Thomas McEvilley, "Development in the Lyrics of Aristophanes," *American Journal of Philology*, XCI, 3, July, 1970, pp. 257–276.

3. See E.R. Dodds, *The Ancient Concept of Progress and Other Essays on Greek Literature and Belief*, Oxford: The Clarendon Press, 1973, and Robert Nisbet, *History of the Idea of Progress*, New York: Basic Books, 1980, p. 45.

4. Heinrich Wöelfflin, "Das Erklaren von Kunstwerken," *Kleine Schriften*, ed. J. Gantner, Basel, 1946, p. 169.

5. Wöelfflin, *Kunstgeschichtliche Grundbegriffe*, 1915, 8th edition, Munich 1943, p. 249.

6. William Rubin, as cited by Peter Fuller in *Beyond the Crisis in Art*, London: Writers and Readers Publishing Cooperative Ltd., 1980, p. 98.

7. Alois Riegl, *Späetromische Kunstindustrie* (1901) Vienna, 1927, pp. 26, 29.

8. Erwin Panofsky, 'Die Perspective als "Symbolische Form"' (1927), *Aufsatze zu Grundfragen der Kunstwissenschaft*, Berlin, 1964, pp. 99–167. Against this Pirenne has argued that Euclidian optics did in fact imply an infinite continuous space like that of Renaisance perspectival renderings. [M.H. Pirenne, *Optics, Paintings and Photography*, Cambridge, 1970, pp. 148ff.]

9. Panofsky, "Der Begriff des Kunstwollens," *Aufsatze*, p. 46, n. 11.

10. Roger Fry, *Reflections on British Painting*, 1934.

11. Suzi Gablik, *Progress in Art*, New York: Rizzoli International Publications Inc., 1976.

12. See John White, *Perspective in Ancient Drawing and Painting*, Society for the Promotion of Hellenic Studies, Supplementary Paper no. 7 (London, 1956) and J.J. Pollitt, *The Ancient View of Greek Art: Criticism, History, and Terminology*, New Haven and London (Yale University Press: 1974), pp. 230–241.

13. Pollitt, op. cit., p. 221. Emphasis added.

14. Samuel Y. Edgerton Jr., *The Renaissance Rediscovery of Linear Perspective*, New York: Harper and Row, Icon Editions, 1976.

15. George Kubler, *The Shape of Time*, New Haven and London (Yale University Press), 1962, pp. 39 ff.

16. Stephen Jay Gould, "Creation Science is an Oxymoron," in *The Skeptical Inquirer*, vol. XI, no. 2, Winter 1986–87, p. 152.

17. Clement Greenberg, "Complaints of An Art Critic," *Artforum*, October 1967.

Father the Void

There is one motherland, stranger, in which we all dwell, and that is the cosmos; there is one father of whom we are all begotten, and that is the void.
Meleager of Gadara (2nd century BC)

It seems that change in the broadest sense is upon this moment of history—this portentous moment at the end of a decade at the end of a century at the end of a millennium—and not just any millennium, but the one which in Judeo-Christian tradition has often been suspected of ushering in Armageddon and Eden. Without intending to affirm any form of Social Darwinism, one may perceive an analogue in the biologists' theory of punctuated equilibrium, which holds that evolutionary change happens not steadily and gradually but in unpredictable bursts following long periods of comparative stasis. The present, on that model, is a heated moment of punctuation: an exclamation point, as it were—but jagged, like a lightning bolt.

At most moments of history the web of causality seems tight; but at some, like this one as we head into the '90s, there seems (perhaps deceptively) to

be some slack in the web. Perhaps decisions are to be rethought, or definitions redefined. Perhaps there is room for action.

To describe this moment as the beginning of a post-historical age is not to make an Edenic statement: it is to say only that this is a moment when the idea of history is being redefined. The Modernist period was dominated by Hegel's view that history had an internal direction and a goal, and that progress was, in effect, a law of nature. Entranced by this faith the Western nations felt that history was on their side, that it was taking them where they wanted to go—to the vaguely conceived spiritual culmination which Hegel had written about. History was more like Providence, really, benignly watching over and guiding.

Behind this myth were hidden motives difficult to acknowledge. History as we have known it happens primarily when one people forces its way into another people's life realm. If everyone stayed at home there'd be no history. A poet once remarked that history was the story of a handful of white guys racing around the world scaring the shit out of everyone else. But as the white guys made history into a story that flattered them, the terms altered. The story called history became a thinly disguised justification of colonialism. The West was declared to be the leader of history, guiding other peoples toward the goal. Voyages of plunder and conquest were recorded as "voyages of discovery," undertaken, supposedly, as altruistic attempts to lead other peoples toward history's culminating spiritual reali-

zation. This logic was not unlike the famous remark of an American officer in Vietnam: "We destroyed the village in order to save it." These reflections suggest that at a not very hidden level the terms "post-Modern," "post-historical," and "post-colonial" are synonyms: at the heart of Modernism was a myth of history designed to justify colonialism.

When the Hegelian myth was applied to art in particular it stimulated a semi-mystical exaltation in which formal developments were seem as the inner meaning of history. Art became the emblem of the soul of Modernism, its spiritual validation—a highly focused realm of evolution-like advances that seemed to guarantee that history was indeed progressing toward some goal. Early post-Modern art—such as the quotational and appropriational work so common in the '80s—with its deliberate confounding of historical sequences, was designed to deconstruct the Modernist myth of historical inevitability. It argued that the artist now must find his or her way to meaning without relying on a providential ally, an hypostatized History which barely conceals the presence of a guiding deity who can no longer be trusted. Art after aesthetics (that is, after the overthrow of the Kantian theory) is, like science or philosophy, a quest for answers (which may come in the form of new questions). Leaving the faith of Modernism behind, the post-Modern artist tracks the future, seeking a face for the unknown.

In the late Modernist period the artist's role was often shaped by a hidden imitation of the scientist: the relentless formal investigation of a single small

area of expression seemed like the incredibly focused and intense explorations in a science laboratory. This aestheticization of scientific method was a parody, based on metaphysics and wishful thinking. Today, however, the artist may in fact come closer to the scientist—the social scientist, perhaps—in a set of investigations which are not locked into a certain shape by a religious belief in their internal momentum, but tentatively proposed with, essentially, curiosity rather than faith.

Alongside the Hegelian myth of history, the second guiding principle of the Modernist period was the Kantian judgment of Quality. The apprehension of value —according to Kant's *Critique of Judgment,* the last and most suspect of the three Critiques—was supposedly a self-justifying and primally simple act of aesthetic reception made without the intervention of cognitive, ethical, or social awarenesses. Lately a more complex and conciliatory idea of quality has been emerging, an idea that involves the fusion of cognitive and social attitudes within the aesthetic presence so that each hides in the other and at the same time constitutes the other by negative implication.

Modernist art also, of course, had cognitive or conceptual elements hidden within its optical surface—such as the metaphysical concepts of transcendence and the sublime. Though these elements now seem otiose, to reject them absolutely (as in classical conceptual art) is itself disguisedly Modernist in its puritanism—an invertedly metaphysical act. The post-Modern counter-proposal is for an impure and

conflated position which gives away no options. It proposes to operate by relativizations instead of puritanical rejections and reductions. The sublime, for example, is still in a relative sense a legitimate topic for art on a variety of levels, from a committed but not absolutist stance to a degraded and ironic one.

In a similar sense something like metaphysics still plays a role, but without reference to an "other-worldly beyond" so much as to an indefinability or unknowableness within the world of experience. It may be defined as an impulse not merely toward the unknown but theoretically knowable (which is the object of science and scholarship), but toward the frankly unknowable. From a classical positivistic point of view the unknowable has not been considered a real topic, as from this point of view a question without the possibility of an answer is not a real question. But today this seems less clear than it once did: art today makes approaches toward the unknowable as it is found in incommensurabilities between culture and nature or between different aspects of culture. The act of focusing attention on specific areas of unknowability assumes that something can be derived from the experience despite the fact that the unknown object of attention will remain unknown. At the least, artists reflect something both psychological and social off that gaze, something that may hint at the face the future will present. In this activity art and criticism are linked in an intimate collaboration. The artist makes unverifiable hypotheses or intuitive proposals about the unknown, and the critic drives out into the verbal open their net-

works of implications. The two activities drive one another onward. Together they comprise an investigative tool which is not fatuous, in that it does not duplicate the methods of science, scholarship, or philosophy.

The area of the unknowable which this moment confronts lies in incommensurabilities between different contemporary cultures in the aftermath of colonialism, and their amalgamations and redefinitions of one another's forms and objects in an infinite regress attempt to get from self to other. (It is an infinite regress because once the self has incorporated an element of otherness, that element is no longer other—it has now become self. So the other flees forever in a flowing process of continual change like Daphne's shape-changing flight from Apollo.) Modernism postulated a pure, essential reality in which each self absolutely was itself, without any admixture of otherness. Yet self cannot be known without an other to establish its boundaries (without not-A there is no A); so otherness becomes a necessary corrolate of self, something that self is never encountered without. Seeking the other, then, one seeks what constitutes oneself by negative implication.

Not least of the problems of the Modern essentialist view is that it leaves no room for change: each self is and can only be itself. Socially this idea appears in Hegel, in his assertion of the integral selfhood or distinctive character of each culture, a doctrine which seems to make significant cultural mixing impossible. This present moment, on the contrary, seems posited on a flowing and changing cultural selfhood,

a selfhood which is constantly opening to the other in an endlessly shifting process. This affirmation of change gives rise to an insecurity, since with selves in flux there can be no real definitions. A definition only applies as long as its subject remains unchanged; granted a continually changing subject, the quest for definition can produce only an infinitely receding trail of implications as one culture seeks to incorporate the meaning of another. The present global trend suggests a continuing amalgamation of cultural streams at the same time that each is sharply refocused on its selfhood, as self and other, or sameness and difference, seek a new balance. Released gasping from the isolation tank of Euro-Modernism, and the linear Euro-centric view of history, culture may seek a global framework of imperfect meaning constructed by the balanced interplay of sameness and difference. This approach would yield a vision which is neither pure synthesis, conflating all cultures into one, nor pure diaeresis, separating cultures out by insistence on an absolute integrity of ethnic identity.

Certain Greek philosophers posited the theory that all human beings are ultimately of a common ancestry. In their Alexandrian colonial period, when Greeks conquered much of known Asia, their guiding idea, or propaganda motif, was of a *homonoia,* or one-mindedness, which would result from the deliberate conflation of Hellenic cultural norms with those of other cultures—a deliberate bowing to and merging with the other. As performative gestures toward this ideal, Alexander and his officers took foreign wives and dressed in the local fashion in each

culture they passed through. Modern European colo-
nialism, however, posited as it was on a belief in the
unchanging essence of cultural norms and forms,
dreaded the other as the corruption of the real. To
"go native" (to "go other") was a terrifying and
doomed project, deeply disreputable, for which it
was believed that one would pay in suffering and
early death. In a culture founded on essence and
hence terrified of the other, deep frustrations of long-
ing to get out arose.

The unitary message of Modernism created a
prison of self with no other to feel itself by, a self
turning endlessly in a cage. Suddenly the self sees a
way out, an open place attained through a multi-
coded semantic structure. Post-Modernism dawns.
A hybrid object attempts to incorporate into itself its
own counterweight or critique—its other. The Mod-
ernist work attempted to present itself as possessing
complete ontological integrity. The post-Modern
work, on the other hand, attempts to embody, illus-
trate, analyse, and exhibit the particular manner of
its lack of such integrity. Thus the post-Modern/
post-historical / post-colonialist / post-aesthetic mo-
ment innately involves pastiche, or meltdown of
elements from manifestly different matrices.
Conflations of elements from different contempo-
rary cultures are glaringly multi-coded. They may
at first have a grotesque look like monsters—mean-
ing the word as in Greek mythology, where it indi-
cates beings possessing attributes of different species
at once. But the point is that essences are not in-

volved; with a little time the grotesque no longer looks grotesque. It becomes a new norm.

There is a feeling of anarchy or freefall when a value structure is overthrown. Some, seeking safe purchase, cling to the value judgment of the passing frame while around them the faculty of taste is relativized and moves as if by its own volition away from the center of critical activity. The living critic comes to realize that the least interesting thing he or she has to offer is a value judgment—such dicta are finally about as relevant to the rest of the world as what flavor of ice cream the critic prefers.

The critic will come to see art as culture and culture as anthropology. Anthropology in turn will increasingly become a means of critiquing one's own inherited cultural stances rather than of firing value judgments in all directions. The critic will see that he or she may investigate, analyse, interpret, compare, gather together and sever apart—but not attempt to enforce his or her value judgments on others; of all things, that will be the most direct betrayal of the reconsidered critical project. The purpose of criticism will no longer be to make value judgments for others, but to sharpen the critical faculty and its practice through all of culture. Ultimately the art historian will come to view value judgment systems as objects of anthropological and sociological interest, not as carriers of truth value.

Considerations of quality in formal terms will not lose their place in the art discourse, but they will be relativized for different cultural settings. Meanwhile,

new criteria of quality will arise. At this moment, for example, the way an artwork relates to place is an issue almost as compelling as the formal qualities of the work itself. Modernism attempted to decontextualize the artwork through a sterilized and idealized gallery space. The art energy was aimed at a beyond from a purified location that suggested a launching pad to other metaphysical planes. Place was related to as Place—as a metaphysical center, essentially otherworldly. Today the relation to place has come down to earth and moved outward into society rather than gazing blankly into the beyond with a gorgeous flush on its face from the distant Hegelian sunset over the horizon. The post-Modern artwork introduces itself to its audience as embedded within an expanding set of causal webs. Its ability to act in the real world, to find areas of slack in the web through which movement and intervention are possible, will depend not on pretended overleapings of causality, but upon a precise sense of location in concrete places. In the Modernist period, if a Third World artist wanted to become modern—or international—he or she simply started to paint in the style of the School of Paris or, later, of New York. This is not at all what post-Modern globalism implies. Rather, it means focusing, refining, embodying, and expressing one's particular identity while at the same time finding a way to inject its expression into the global discourse—a way to make it useful to others.

At the center of the work personal sensibility interacts with group location or ethnicity—the place the artist and his or her ancestors entered and were

shaped by the causal web. Obliquely intersecting this is the impetus of the place where the artwork is (physically or mentally) made; to honestly acknowledge its embeddedness in causality the artwork must somehow reflect the conditions of the place where it takes form. Another vector which sometimes will affect the being of the work, and sometimes not, is the conditionality of the place where it is to be exhibited, where it is to exert its effect, to become a cause in its turn. Surrounding these boxes within boxes—or contexts within contexts—is the grander matrix of the global frame. At their greatest potential, the meaning and presence of the artwork simultaneously contract to an intense focus on the particular and expand to a global scale through the incorporated awareness of the work's place within a reconceived history. The idea of the global village is not new—but it has been two thousand years since there has been an historical moment when it might be culturally realized.

When Diogenes was asked the name of his home town, he replied, "The world."

INDEX